Fast Sketching Techniques

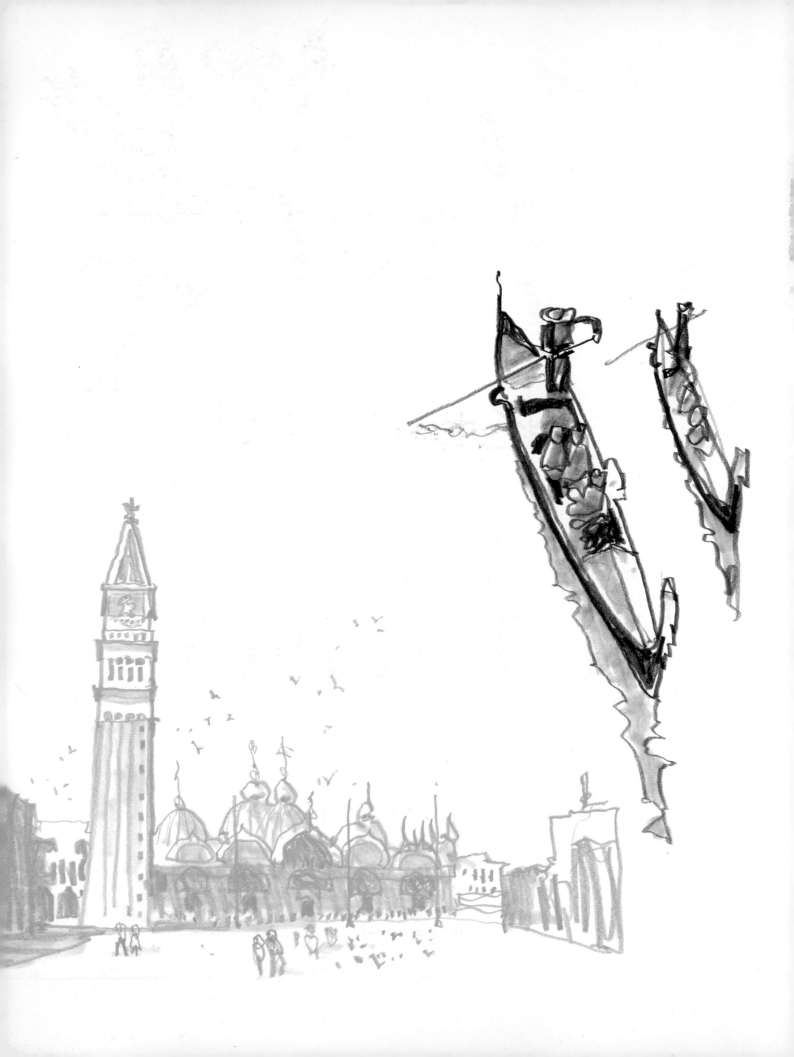

fast

Sketching

techniques

David Rankin

NORTH LIGHT BOOKS
CINCINNATI, OHIO
www.nlbooks.com

I'd like to dedicate this book to my wonderful wife, Deanna. She travels the world with me and provides me with another set of artistic eyes and creative ideas.

Fast Sketching Techniques. Copyright © 2000 by David Rankin. Manufactured in China. All rights reserved. No part of this book may be produced in any form or by any electronic or mechanical means including information storage and retrieval systems without permission in writing from the publisher, except by a reviewer, who may quote brief passages in a review. Published by North Light Books, an imprint of F&W Publications, Inc., 1507 Dana Ave., Cincinnati, Ohio 45207. (800) 289-0963. First edition.

Other fine North Light Books are available from your local bookstore, art supply store or direct from the publisher.

04 03 02 01 00 5 4 3 2 1

Library of Congress Cataloging-in-Publication Data
 Rankin, David, 1945–
 Fast sketching techniques / David Rankin.
 p. cm.
 Includes index.
 ISBN 1-58180-005-3 (alk. paper)
 1. Drawing—Technique. I. Title.
NC730 .R36 2000
741.2—dc21 99-087547
 CIP

Designed by David Rankin
Cover designed by Stephanie Strang

About the Author

David Rankin, a graduate of the Cleveland Institute of Art, is an award-winning professional watercolor painter whose paintings have been featured in more than forty-five museum exhibitions in Japan, Sweden, Canada and across the United States. His work has been featured in numerous books and magazines, including publications such as *American Artist, Wildlife Art* and *International Wildlife*. His creative efforts take him around the world in search of inspiration for his masterful watercolors.

He is on the board of the world's oldest association of animal and wildlife painters and sculptors—The Society of Animal Artists—and has twice won its top award, the Award of Excellence. Most recently, his painting *In the Heat of the Day* was awarded the prestigious Leonard J. Meiselman Memorial Award for Representational Painting at the 1999 annual members exhibition, which opened at The Cleveland Museum of Natural History.

David refers to his work as "natural abstraction," a term he uses to define his use of realistic images based on very abstract design principles found in nature.

He feels his artistic odyssey really began in 1970, when he made his first extended journey to India for advanced training in his lifelong study of yoga. It was in India, especially during seven summers in Kashmir, that his sketching and painting technique gradually evolved. "I often say that it was India herself that changed the way I draw and paint, for it was my extensive travels there that brought to light the inadequacies in my drawing style. I was literally forced to develop more effective methods for creating painting ideas on location as my desire to paint a wider range of subjects grew."

Although his main emphasis is still India, he also paints the Southwest, Florida, the Great Lakes region and his hometown of Cleveland, Ohio.

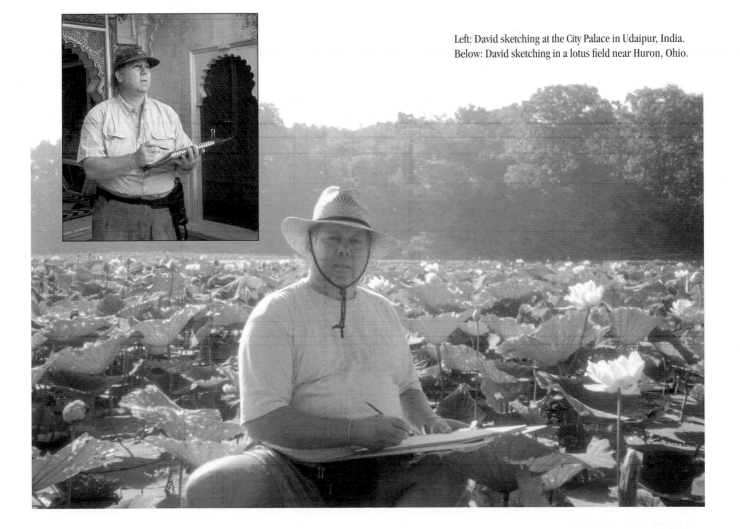

Left: David sketching at the City Palace in Udaipur, India.
Below: David sketching in a lotus field near Huron, Ohio.

Table of Contents

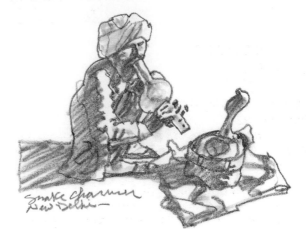

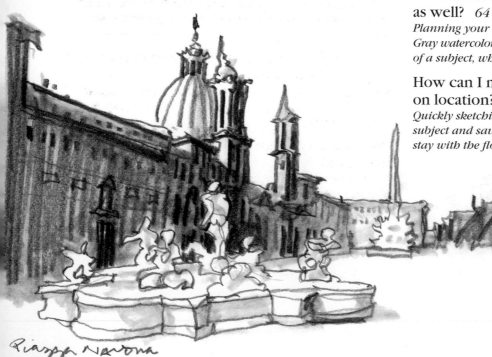

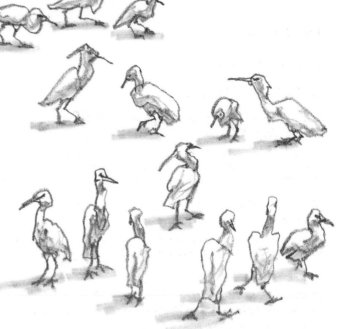

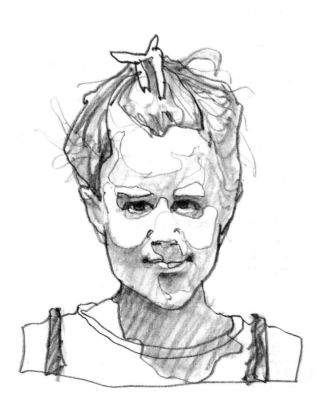

Introduction

Sketching is a unique artistic skill that is dramatically different from what is normally called drawing. It is the ability to put thoughts, ideas, memories, dreams and present-moment perceptions down on paper very fast.

Sketching is the art of putting thoughts, ideas, memories, dreams and present-moment perceptions down on paper very fast.

In everyday experience, my ability to sketch allows me to work in the most creatively rewarding way possible, directly from my subject—completely independent from my cameras.

This ability to observe, study, sketch and refine ideas in the same moment I am perceiving a subject gives me maximum creative freedom. It allows me to react immediately and spontaneously to whatever is before me, right then, rather than waiting for slides to be developed in a few hours or days.

Before I developed my sketching skills to the level they now are, most of my painting ideas were captured and recorded on 35mm slide film, to be developed and refined into paintings at some later time. I had always been conflicted by this working method, for I seldom developed a painting from one slide image. Even with my clearest ideas, I found I was usually using pieces of as many as five to ten different photos to develop an idea for even a simple composition in a painting. I also found that because I wasn't doing much on-the-spot work to refine and develop my ideas, I took a lot of slides, which became very expensive!

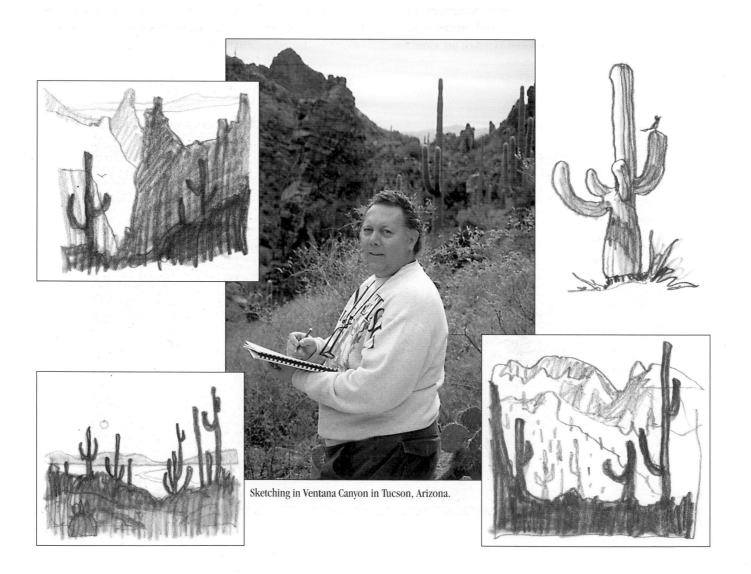

Sketching in Ventana Canyon in Tucson, Arizona.

It never occurred to me that the reason I was taking so many slides of a subject—capturing its lighting, details and overall design elements—was because I wasn't working on these ideas on location. I was actually postponing the real creative work until I got back home. Then I would set about developing my painting ideas working from literally thousands of slides.

Finally, I realized how limiting this was and began working on improving my sketching technique.

Travel and logistics are always limiting factors in my work. That's why I wanted to develop a sketching style that would allow me to work as fast as possible. It finally dawned on me that with only photographic references to work from, what I was really missing was in-the-moment impressions, inspirations and experiences. I was having to rely on my memory and bits and pieces of ideas I had captured through the impersonal lens of my cameras, with very little of my creative interpretation.

Before I developed my sketching skills, most of my painting ideas were recorded on 35mm slide film.

I now understand just how important my initial live moment sketching is to my best work. My ability to sketch quickly and creatively, in virtually any circumstance, has liberated me from my slavish use of cameras and their seductive ease of imaging. My ability to sketch fuels my painting efforts, and allows me to develop ideas and visualize them through into finished artwork faster and better.

I still utilize my cameras extensively, but now as creative tools to back up my sketches and watercolor field studies with reference images.

This book presents my most precious, personal procedures for sketching, both in the field and in my home studio. I offer them to you and wish you the joy of traveling the world as an artist—with a sketchbook in one hand, your pencil in the other and your camera in your pocket.

DAVID RANKIN

Trekking in Kashmir.

Old Styles and Methods Just Didn't Work

The process of changing the entire way you work doesn't take place over night. With me it took years, in fact more than a decade, to even grasp the real nature of my problem.

Shown on this page are two of my early styles. Below, and on the following page, are examples of my art-school drawing style for the human body. Also on this page is an illustration style of linework I developed and used in my career after art school.

As long as I was in a classroom-like setting, these styles worked fine. I had lots of time to experiment and noodle every tiny detail. Even after art school, I utilized these styles in my illustration work for magazines and advertising.

The difficulties in my drawing style didn't become evident until I began spending my summers in Kashmir in 1974. I had the desire to sketch or paint some of the wonderful things I saw and experienced, but was shocked to realize that my existing skills, though substantial, were simply not the right ones for the job. I compensated by switching to my 35mm cameras when I wanted to record

something for later.

Everything before me was new and strange—and artistically captivating—all at the same time. But the drawing skills I possessed were so slow that I had trouble drawing anything other than landscapes that didn't move. I had traveled to the other side of the world with drawing skills that were really meant for studio work.

The factor limiting my creative efforts the most was that the drawing styles I was good at were simply not designed for fast field work. The illustrations from my art school sketchbooks on the facing page show a classic style of dealing with the human figure.

The classic crosshatch style shown is created slowly and delicately with light, tentative contours searching for a structure. Then you delicately build up the shading defining the form with crosshatched lines. I took four years of drawing classes to perfect this style. It is indeed a lovely style, but it's a lot like taking Latin in high school—there just isn't much practical use for it outside of school. It doesn't work for sketching live subjects; it's just too slow.

In art school I practiced hour after hour with live models, plaster casts and other classical sculpture, but it didn't prepare me for working with people in unposed settings.

One of the things that has continued to fascinate me is anatomy. In art school I excelled at this classical style. I thought for a time that I would go into medical illustration, but that required a premed stint that I wasn't prepared for.

My understanding of human and animal anatomy has helped me throughout my career, but I now believe that you don't really need such an extensive knowledge if you learn to see and sketch visual shapes more accurately.

Chapter One
The Basics

What is the difference between a drawing and a sketch?

This is *not* a sketch! It is what I refer to as a rendered illustration of Canada geese. Because it was created with a pencil, many people may automatically call it a sketch, even though it took more than forty hours to create. If you assume that this is the degree of finish you are striving for when you are sketching from life, you will be unhappy with your experience. The most essential difference between a drawing and a sketch is the speed at which they were drawn. This is a studio illustration, worked on slowly from good slides.

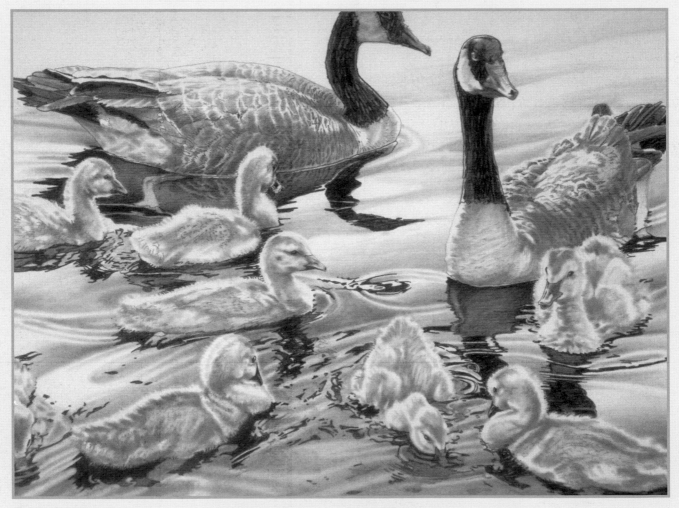

Drawing

Drawing is what we normally do when our subject doesn't move around much and we have lots of time. Drawing is like writing a story in longhand. Drawings can be very realistic, detailed, elaborate and complete in every value. Drawing is slow.

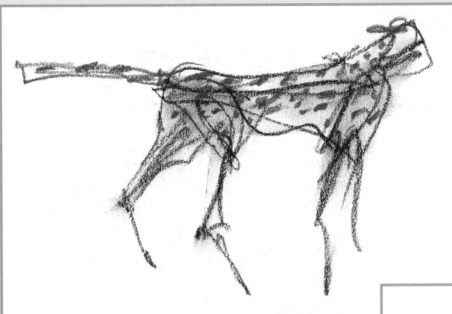

Here I've chosen a perfect example of one of my quick sketches, done from a cheetah at the Cleveland Metroparks Zoo. The whole purpose of sketching is different from drawing. When you sketch from life, you're simply trying to capture visual and emotional impressions of subjects. You're working fast. Study the movements, the form, the postures and the intrinsic characteristics of a subject moment by moment. You're only trying to capture something of its essence in your sketch.

Sketches are the fastest and most creative thinking that you do with a subject. They are intense, loose, rapid and spontaneous. They don't look like a slower, more deliberate drawing.

Sketching

Sketching is what we do when our subject tends to move, or when we're working fast to develop an idea. Sketching is more like taking shorthand—quick, loose, impressionistic and limited to only a few values. Sketching is fast.

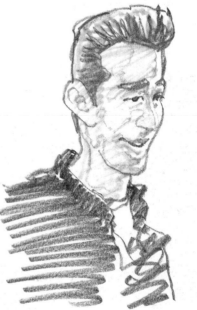

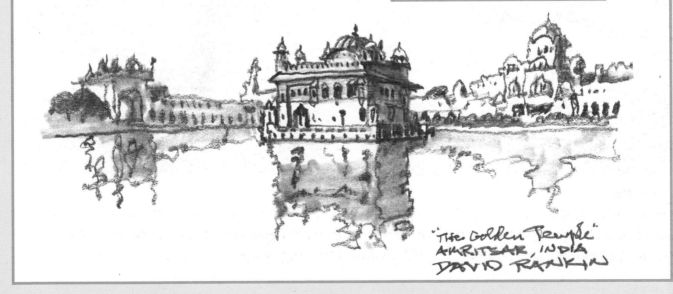

"The Golden Temple"
AMRITSAR, INDIA
DAVID RANKIN

Seeing the Difference Between Sketches and Drawings

Here is a typical sketch. I was doing painting research for a poster project for the Smithsonian Institution's Conservation and Research Center. While there, I had the opportunity to study these very rare Hawaiian birds.

The enclosures had a lot of tropical plants and limbs, and these very tiny birds were zipping about all over the enclosure. When they would land it was only for a moment or two before darting off again.

In situations like this, artists have few options. This is an example of a situation in which sketching skills are necessary. I had my cameras, but trying to focus and photograph these birds through their mesh enclosures, in low-filtered light, as they jetted about their space was next to impossible without a lot of preparation and setup.

Catching only glimpses of them through the foliage, retaining a few moments' mental image of their unique postures or physical features and rapidly sketching these brief moments in time allowed me to create these images.

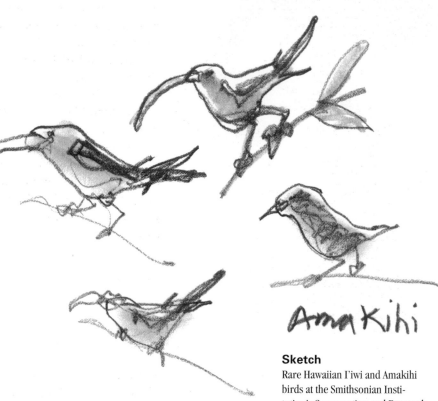

Sketch
Rare Hawaiian I'iwi and Amakihi birds at the Smithsonian Institution's Conservation and Research Center in Front Royal, Virginia.

Drawing
Wood ducks and a mallard on Shaker Lakes, Shaker Heights, Ohio.

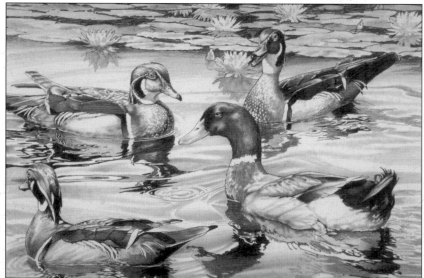

This is a rather elaborate drawing of wood ducks and a mallard for a limited edition print. Can you see how much more finished it is? This illustration took about forty hours of very careful drawing, yet many people still refer to these kinds of images as sketches.

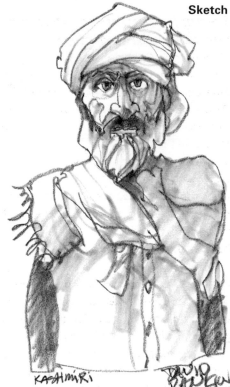

Sketch

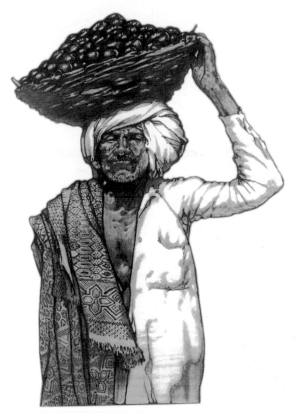

Drawing

The drawing of the farmer to the left was created in my studio working from my slide reference and took about three hours.

The sketch of the Kashmiri shepherd to the right took six to seven minutes in the streets of a Kashmir hill station called Phalgam.

Where the sketch looks loose, fast and spontaneous, the drawing is much tighter and more detailed. In the drawing, you can see the designs in the farmer's shawl.

Study the detail in the illustration of a red crowned crane shown on the left, done from a 35mm slide reference in my studio. You can easily see the higher degree of finished detail as compared to the five-minute sketch of the turkey below. Sketches are for your fastest thinking about a subject. Work quickly and only suggest detail and form with rapid shading.

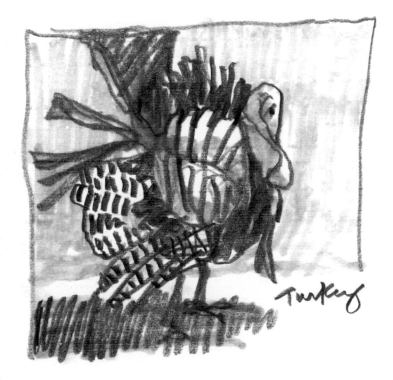

Drawing
Red crowned crane at the International Crane Foundation in Baraboo, Wisconsin.

Sketch
Turkey at Greenfield Village in Detroit, Michigan.

15

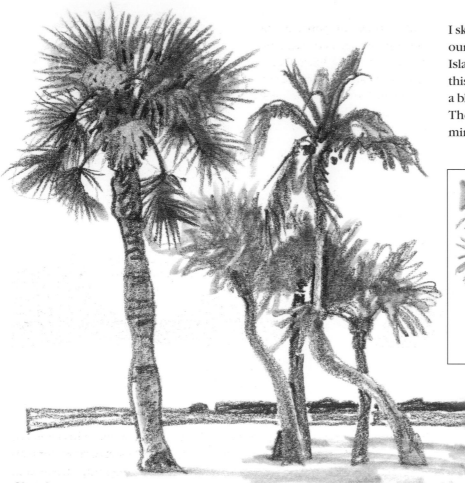

I sketched these palms from the Tiki Bar at our hotel on Estero Beach (that is Sanibel Island on the horizon). With sketches like this, the pencil pressures and shading with a blending tool allow nice value gradations. The total sketching time was five to ten minutes.

Sketch
Gulf coast palms on Estero Beach, Florida.

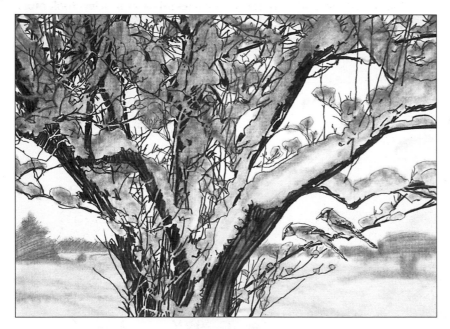

Compare the spontaneity of the palm sketch above to the very careful rendering of the positive and negative branch structure in this image of blue jays in an apple tree, the reflected light modeling of the snow caught in the branches, and the birds themselves.

This drawing took three days and required numerous preparatory sketches and studies to establish the design. This type of drawing and the actual way it was drawn are too slow for field work.

Drawing
An early April snowfall at the Holden Arboretum in Kirtland, Ohio.
Original 14" × 18" (36cm × 46cm)

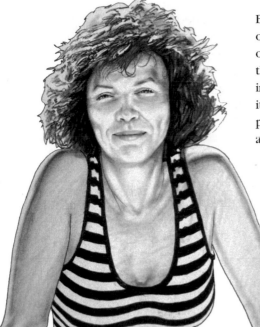

Both of these are portraits but one is tightly rendered and the other is loose and fast. Don't think you can create the drawing on the left in a few minutes; it took about three hours. The portrait on the right took only about five to six minutes.

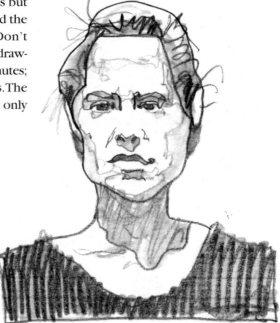

Drawing
A pencil drawing of my wife, Deanna, teaching yoga.

Sketch
Our friend Kathryn.

You simply cannot take time to draw all the subtle details when you are sketching people as they move about. A sketch is the result of your moment-to-moment observations of small details, postures or lighting effects that catch your eye—a quick attempt to freeze your perceptions and put them on paper.

The pencil illustration of the young man mixing oil paints took more than three hours and is highly detailed, while the women carrying laundry on their heads were sketched in a just a few moments from my taxi at a railroad crossing in southern India.

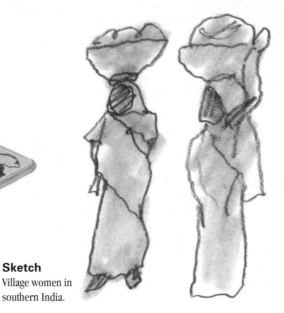

Drawing
Artist's apprentice in Bombay, India.

Sketch
Village women in southern India.

Knowing When to Sketch

When sketching from life, use your skills to rapidly create impressions from the world around you. When you are back in your studio developing ideas and compositions from your field sketches or photo reference shots and you want to visualize elements quickly, use your sketching skills.

When your subjects are motionless or you have lots of time to develop ideas, it doesn't matter how slowly you draw. The trick is knowing when to use sketching speed. Don't try to draw when you should be sketching.

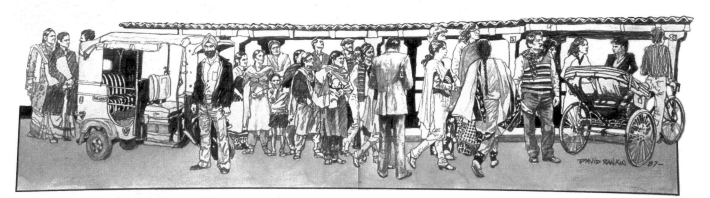

Drawing

The above drawing is what I refer to as an illustration, as is the drawing of my wife teaching her yoga classes. In these illustrations I use a similar drawing style of line and shading. These kinds of drawings can take many hours and require really good photographic reference to establish details and subtlety.

Compare these to my on-the-spot sketch of a snake charmer in New Delhi. Can you see the visual difference in the results of each style?

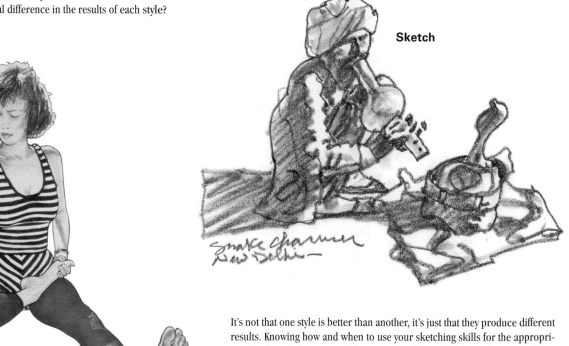

Sketch

It's not that one style is better than another, it's just that they produce different results. Knowing how and when to use your sketching skills for the appropriate situations is important. You want to be able to sketch anything, anywhere, anytime with confidence and good results.

Drawing

Creating the Right Image

Understand your goal when sketching fast. Visualize the kind of image you're striving to create. If you expect to create an image like the one to the right in just a few minutes, you'll be disappointed. But for the bagpiper below, this is a realistic goal. It took less than five minutes to create, and represents a good example of what you can expect to produce after learning how to sketch properly.

Sketching is as much a state of mind as it is a drawing technique. I want you to be able to move through this world as an artist, observing it intimately and creating visual images of it in just a few moments. Artists discover inspiration in things others pass by a thousand times, and they create works of art out of nothing other than their own perceptions.

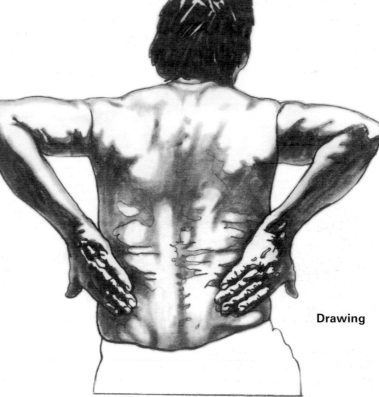

Drawing

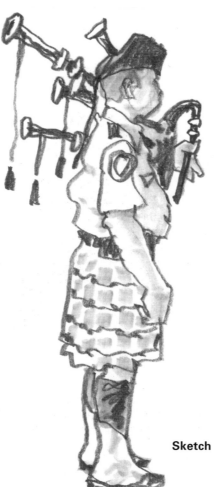

Sketch

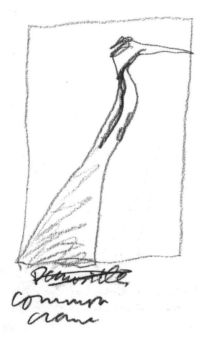

Perrotte,
Common
Crane

Changing for the Better

By 1985 I had been coming to India regularly for fifteen years. From my earliest trips into Kashmir, I had been struggling with my drawing style. I wasn't able to sketch people or animals with enough speed to actually capture something significant. And traveling into extremely remote regions of Kashmir on horseback didn't make it easy to stop for any length of time to sketch or paint.

This became frustrating for someone as visually oriented as I am, so I began to make a concerted effort to try new things and new ways of drawing. It wasn't until one day at the New Delhi Zoo that things began to change for the better.

On several daylong sketching excursions something happened that suddenly opened my eyes and began to revolutionize how I sketched. Here you see some of those sketches, beginning at left with the one of a common crane.

I was working so fast with live birds that I unconsciously began to omit detail altogether. That was the turning point. I focused only on capturing a simple likeness of the species with linework contours and very quick, scumbled blacks. It was like magic to me; I was suddenly able to rapidly draw a simple visual of a live creature with relative ease.

I was amazed to discover that I could

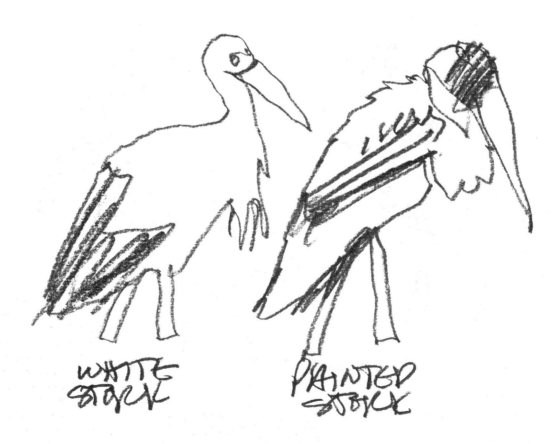

WHITE STORK

PAINTED STORK

create sketches of very tiny birds, like the bee-eater shown on the right, as well as six-foot-tall storks. I was so focused on getting the several basic shapes that comprised the bee-eater that I didn't even draw the tree limb it was perched on.

Those few days of sketching in the New Delhi Zoo represented a dramatic turning point in my ability to simplify my drawing and to begin *sketching*. They also completely opened my eyes to a new way of looking at subjects. You have to refine your ability to focus perception so you look for and see shapes, contours and structure rapidly and clearly.

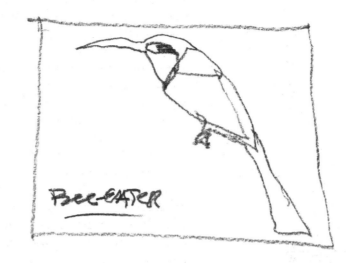

All of these sketches are shown at their actual sketchbook sizes. If subjects move, keep your sketches small and omit details. Look for and sketch identifiable visual characteristics of your subject.

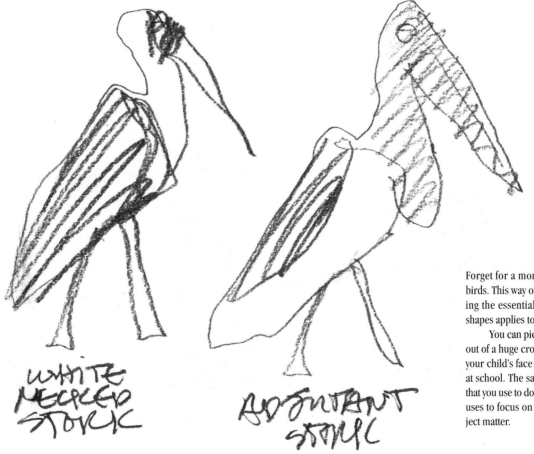

WHITE NECKED STORK

ADJUTANT STORK

Forget for a moment that these are birds. This way of seeing and capturing the essential, most identifiable shapes applies to any subject.

You can pick your friend's face out of a huge crowd at an airport, or your child's face in a sea of children at school. The same perceptual skill that you use to do that is what an artist uses to focus on specific visual subject matter.

Focusing on Linework and Shapes

Here are two pages of sketches I did when I really began to hone my skill at focusing on the simplest of shapes using only black linework with a Pentel felt-tip pen. You can see from these tiny sketches that you can capture a lot with just the linework. It was some time before I developed the shading procedures I now utilize.

Because I limited myself to using only the most elemental black linework to establish overall posture and characteristics, I worked very small—the images on both of these pages are shown at their actual sizes.

An emphasis on linework allows you to increase your sketching speed dramatically, and forces you to see objects more clearly.

adj. wading

storks.

white necked

Bittern

adj. Taking son.

Printed Landing

white Egrette

Rosy Pelicans

Demoiselles

Hornbills

Greater Hornbills

Pink Flamingos

Rookery Landing

What are the basic tools and techniques for sketching?

The first thing you need to do to work with this technique is to get the right sketching materials. You cannot master this technique with a 2B or 4B pencil, let alone anything harder.

The best pencil for this technique is the 9B Pentalic Woodless Pencil. This is a 100 percent graphite pencil made by Grumbacher.

Pictured are all the tools I recommend.

9B Pentalic Woodless Pencil

Berol China Marker

Berol Turquoise #375 6B

Design Drawing 6B #3800 by Eberhard Faber

6B General's Charcoal Pencil #557 Ex. Soft

Graphite blending tools in various sizes

Kneaded eraser

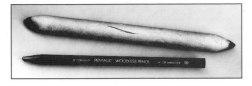

Try these exercises with a 9B graphite pencil and a blending tool. Notice how the graphite pencil reacts to hand pressure. If you press too hard it will break in half, so be careful.

1 Draw a wavy line.
2 Using your blending tool, smudge this line so it has a midvalue gray around it.

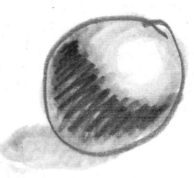

1 Using your graphite pencil, lay down a scumbled mass of lines at various angles.

2 Then simply blend over this mass of lines with your blending tool so you create a soft gray tone right over the lines.

1 Now draw a ball shape. Lay in an arc of scumbled lines as shown, and then use your blending tool to create a gray shade over the ball, leaving a clean, white spot for a highlight.
2 Use your blending tool to add a soft gray cast shadow.

Limit Sketching Values

In order to sketch rapidly you must limit yourself to three or four main values. This gives you a dark value for linework and deep shadows, one or two midvalue grays for shading and, of course, the white of the paper. Any more elaborate and you'll be drawing, not sketching.

In most situations I think of the gray-shaded values as one. With the ball above, for instance, you've got the dark linework and the shaded gray tones, and you've used the white of the paper for the lightest value. This is all you really need to complete a sketch fast.

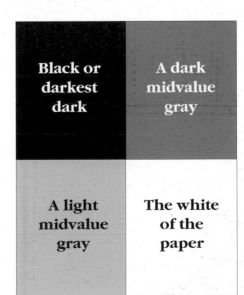

Black or darkest dark	**A dark midvalue gray**
A light midvalue gray	**The white of the paper**

What is the fastest way to improve my sketching?

Copying is the fastest way to improve. We learn things by first seeing how they're done and then trying to do them ourselves. In most cases we try to copy the skill precisely as instructed until we get it right. This is the most basic method of learning anything.

When I was young, my father took my brother and me fishing on Bass Lake, just south of Empire, Michigan. He carefully showed us how to bait our hooks and unsnag our reels. Then he taught us precisely how to hold the fishing pole and cast up near the lily pads. He did this again and again until we learned how to cast and use a fishing rod correctly.

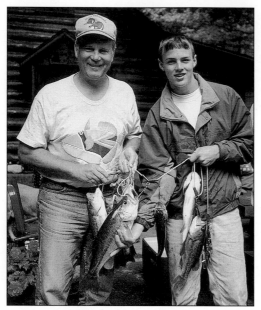

My brother, Rick, and my nephew Ryan with an evening's catch.

My father was the best fisherman I've ever known, and my brother, Rick, and I wanted to be able to cast exactly like he did. So we copied his every move and nuance and learned how to fish.

I still remember an art class when I was just a child in which the teacher showed us how to draw a pig with three circles. It was magical. We all copied her three-circle trick, and bingo! We could all draw a pig too.

As we grow older, we are taught again and again that copying is wrong. If you are copying Degas's style in order to create Old Master fakes that you then sell as originals, that is wrong. But the fact remains that copying is one of the most time-honored training methods in the art world.

It forms the basis of the whole concept of apprenticeship.

During the Renaissance, an art student would become an apprentice in a famous artist's studio. The student would then try to diligently copy the master's work in order to learn techniques and procedures and rise through the system.

A friend of mine, now a surgeon, wanted to intern on the other side of the country at a specific medical center so he could study with and observe the surgical technique of the best hand surgeon in the country.

Copying in order to learn new skills or refine old ones is not only OK—it is the best and fastest way to enhance your abilities.

Copy my sketches in order to learn my technique. This is the way artists have been learning for hundreds of years. So pick up your 9B, grab your sketchbook and let's start sketching.

Learn by Copying
When I was five years old, the three-circle pig was a really cool trick. Copying is the best way to improve your sketching technique.

Deer Exercise

In the fall of 1998, I was honored to be chosen as the featured artist for the Smithsonian Institution's Conservation and Research Center's (CRC's) fine art exhibition in Front Royal, Virginia. CRC is home to a wide diversity of endangered species from around the world, including the Eld's deer.

I sketched this female Eld's deer in about three minutes; now see how fast you can sketch it.

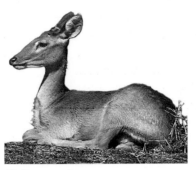

Reference image

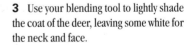

1 Begin by drawing the outline shape of this deer resting on the ground with her legs folded under her. This is the stage of sketching that has to be done the fastest. If you can quickly capture the general outline shape of a live subject, you can slow down a bit with the rest.

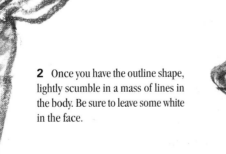

2 Once you have the outline shape, lightly scumble in a mass of lines in the body. Be sure to leave some white in the face.

3 Use your blending tool to lightly shade the coat of the deer, leaving some white for the neck and face.

Should I shoot reference photos?

Using a camera to shoot reference photos is not a problem. The problem comes when you allow the camera to become your primary source for imaging ideas. You can get so used to creatively thinking through your camera lens that you forget you have fingers and a pencil.

The fact is that most professional artists do frequently use cameras. I am one of those artists. I use 35mm cameras extensively in my professional career. In fact, I now have incorporated camcorders into my efforts as well. I have always been good with cameras and I love how they allow me to record tons of visual information in a fraction of a second. Using cameras, camcorders and computers can enhance your skills, but shouldn't replace your sketchbook.

Knowing what kind of imaging aids to use, and when to use them, is important. It's a question of how you actually work—both in the field and in your studio.

For more than twenty years I have lugged around large, heavy 35mm cameras, and now I have camcorders as well. What I now recommend is that you add to your photographic equipment by purchasing a small 35mm camera that fits in your pocket and has telephoto capacity. My Minolta Freedom Zoom goes from 38mm to 140mm.

Choosing a small but useful camera will allow you to change the way you work. You can walk around all day with your sketchbook and pencils in hand, instead of a camera. You still have the ability to capture things on film—let's face it, there are times when you really need to photograph something quick—but you are still using your eyes and hands as your main tools for developing creative ideas.

When to Use Your Camera

1 When there's no time to sketch.
2 When the subject is moving so fast that you need to freeze the action to study it more carefully—reflections in water, sports action and running animals are some examples.
3 For portrait work, to remember more precise visual information.
4 To capture specific or unusual lighting effects.
5 For expansive or intricate landscape features, lighting or details.

Minolta Maxxum SLR with 35–105mm zoom lens

This is my workhorse. It's great for everything, but much heavier and more cumbersome than my small Freedom Zoom.

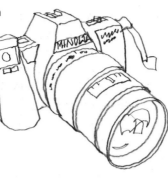

Basic Imaging Rules

1 Think with your pencil first.
2 Use your camera to back up your ideas.

The most creative work you do is with a pencil, not a camera. It's not that you shouldn't use a camera, but you must use it correctly.

Sketching is the closest thing to perception—there's only you and your subject. When relying exclusively upon the camera, you miss the opportunity to explore your subject in the present moment.

Explore the world with a pencil, then back it up with a slide or photographic print. Once you're back in your studio, you'll have everything you need to maximize your creative visualization.

Minolta Freedom Zoom with 38–140mm zoom lens

This camera fits in my pocket, travels with me everywhere and allows me to concentrate on sketching.

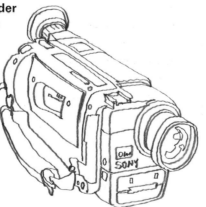

Sony XR Hi–8 Camcorder with 72x Digital Zoom and Night Shot

This camcorder is excellent for very low lighting conditions and gathering huge amounts of visual information easily, especially when sketching isn't possible.

Italy Sketchbooks
For me, travel to far-off lands awakens
my senses and inspires me to paint.

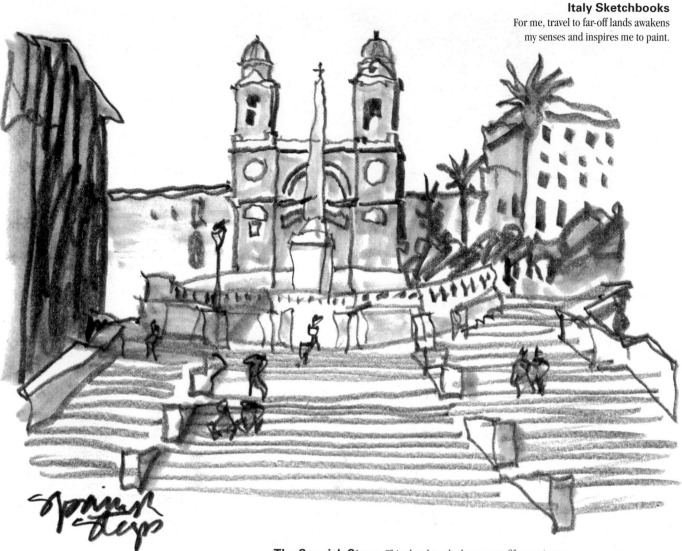

The Spanish Steps This sketch took about ten to fifteen minutes.

Anyone Can Take Snapshots

Like many artists, I gradually became far too dependent upon my camera when traveling. It wasn't that I couldn't draw. It wasn't that I didn't want to work on location. I simply had never been taught the basics of how to actually work effectively outside my studio.

Remember: Everyone takes pictures when they travel, but it takes an artist to create an image with only a pencil.

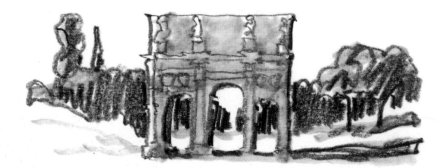

Arch in the Roman Forum This sketch took about three minutes.

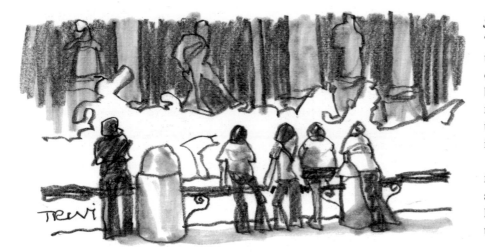

Sketching Tourists

The theme for this day was tourists. At the Trevi Fountain, I simplified the complex fountain sculpture to unembellished shapes and outlines and focused most of my attention on capturing the unique postures of and lighting on the people.

In reviewing sketchbook images for this book, I saw that the sculptural wall linework is too heavy. I could have created more depth with a lighter touch in the background.

Rome's Famous Trevi Fountain
This sketch took about five minutes. The one below took fifteen.

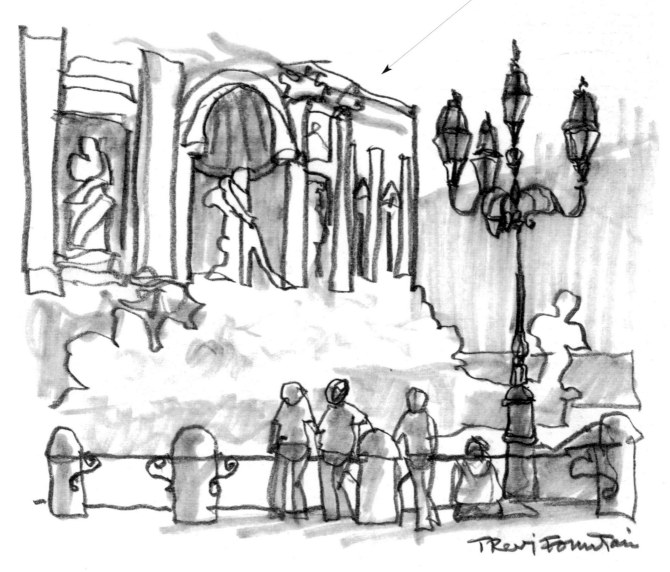

31

How can I increase my sketching speed?

Practicing rapid linework is the key to increasing sketching speed. This is what has to be sketched the fastest. Since the quick creation of linework is so important to sketching, give this exercise a try: Glance back and forth at my sketches of birds in the New Delhi Zoo. Try to replicate the linework in your sketchbook as quickly as you can. They don't have to be exact copies, only close approximations of these studies.

The most important goal of this exercise is to see if you can in fact sketch *faster.* Set a clock with a second hand in front of you. Time yourself and see how long it takes you to re-create some sketches that look similar to the ones below. After you've done this a few times, try the same sketches again, only this time do each sketch in no more than sixty to ninety seconds. It helps if you can keep the tip of your pencil or pen in contact with the paper as much as possible.

Observe your subject intently, looking for recognizable shapes and postures that you can quickly replicate. These kinds of exercises will help you increase your speed and recognition skills.

Adjutant Stork

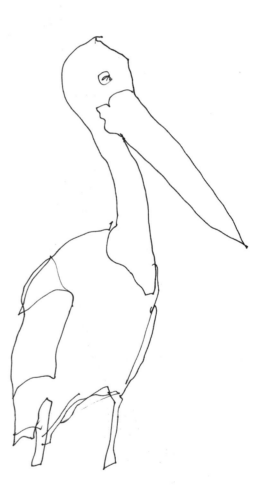

Black-Necked Stork

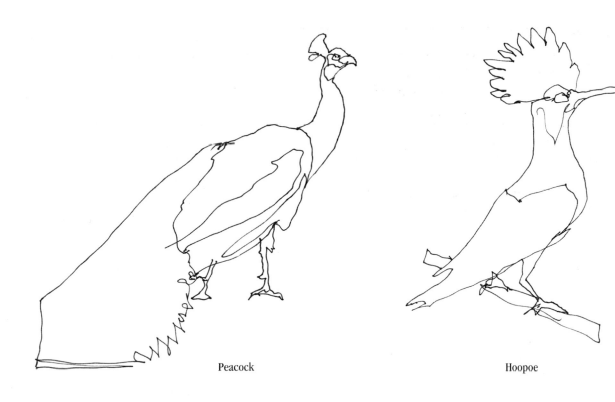

Peacock

Hoopoe

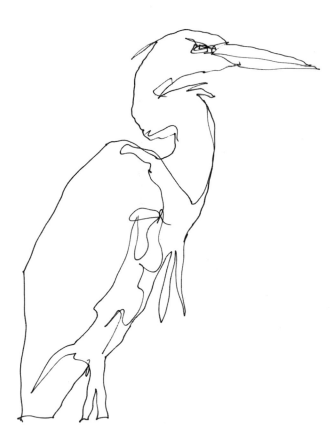

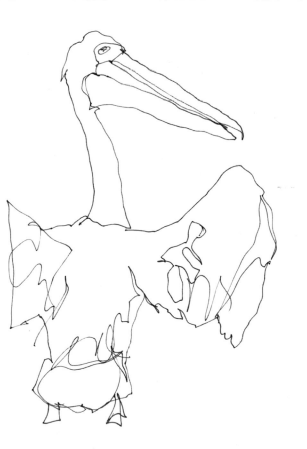

Egret

Rosy Pelican

Developing Shading Skills

It took me several years to effectively deal with the shading of my sketches without using crosshatching or some similar style. In this early sketch below of two white peacocks at a

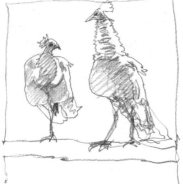

small hotel in Rajasthan, India, you can see how I had begun to add shading with a fairly detailed scumble of lines to define the shadow areas. This also proved too slow and fussy.

white peacocks—RAJASTHAN

At that time I was still trying to make a 2B or 4B pencil do what I wanted. They were OK, but they weren't dark enough and they just didn't blend well.

That's when I began to blend and shade the shadow lines with an artist's stump, what I call a blending tool. This proved fast enough for rapid field work, with the wonderful added benefit that it often resembles a light watercolor wash.

Can you see how simple it was to shade this sketch of an Indian Jungle Tree Pie this way? Note how I darkened the head just by pressing down a bit harder. The blending tool allows you to create a greater range of gray values than with any other drawing tool, plus it is extremely fast.

Tree Pie

yellow

cattle egret

Above: This small Indian Jungle Tree Pie on a limb was the first sketch of these birds. The other two larger ones grew out of an entire afternoon of sketching at the Jogi Mahal Palace inside Ranthambhore Tiger Sanctuary in Rajasthan.

Note how little linework there is in the cattle egret. A few simple contours and facial details are all that's shown. What nails it is the rapid shading with the blending tool.

Also notice how the grass is just a quick mess of lines with a bit darker shading in the grass shadows—fast and effective.

The Three Basics of Fast Sketching

1 **Black linework** defines the structure and detail.
2 The **blending tool** creates the grays and fully defines the whites.
3 **Whites** establish the points of interest and complete the overall tone and mood of any subject.

Shading Creates the Magic

Although the most crucial and fastest stage of any sketch is the initial linework defining essential shapes and details, it is the shading that provides volume, light source and magic.

Once the basic structure has been captured with linework, the blending tool makes shading easy and controllable. Use the blending tool almost like a paint brush. It can make thin, light, soft-edged lines, wide areas of gray and darker grays if you bear down.

This unique combination of a dark line blended into gray shading to define light values and the white of the paper allows you to create a magical quality in the sketch in a matter of moments.

Fast, Creative Thinking

Keep in mind that the central purpose of sketching is to facilitate rapid creative thinking about your subject. The ability to sketch fast and effectively allows you to consider numerous visual ideas in the shortest amount of time.

You want any mistakes you might make to be in your sketches, not your finished artwork. Therefore, anything that helps you get to your painting faster and better is great.

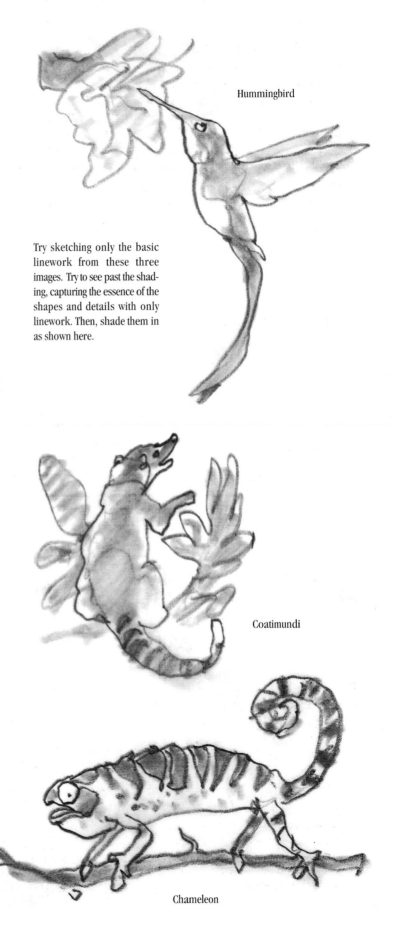

Hummingbird

Try sketching only the basic linework from these three images. Try to see past the shading, capturing the essence of the shapes and details with only linework. Then, shade them in as shown here.

Coatimundi

Chameleon

How can I improve my observation and recognition skills?

The ability to see and easily recognize basic shapes in virtually any subject is essential. As a mental exercise, do sketches and studies from memories of places you have been and things you have seen.

If you work even a little on your perceptual recognition skills, it will pay off in a noticeable way in your sketching skills.

The idea is simple in theory, but harder in practice. Virtually everything you see each day of your life is actually taking shape inside of you—in your mind.

Our sense of sight forms intense and often lasting images in the mental and emotional fabric of our inner nature. Some reappear in our memories or daydreams, while others reappear in sleep as dream images. The images important to artists I call *afterimages*. These are the present-moment experiences of your daily life that are retained in your mind for a short time after you look away from a subject.

As my sketching skills evolved over the years, I realize that this is in no small way due to my ability to perceive these afterimages with clarity, retaining them long enough to sketch them.

It's just like hearing a song on the radio and not being able to get it out of your head all day. All of our senses have the ability to modify our moment-by-moment experience. If you can retain your visual memories for a moment or two longer, it will help you sketch.

Explore Your Visual Nature

Can you remember what you did on your last vacation? Where did you go? Where did you stay? What was your favorite part of the trip?

If you think back to your last vacation, it gradually takes shape in your mind's eye in bits and pieces. As you remember, visual images spring back into your awareness. Usually

Improve your sketching by paying more attention to afterimages.

these images are rather vague. But if asked to do a drawing of something from your trip, you'd be surprised at what would come back.

This mental visualization skill is an elemental feature of our consciousness. For artists, it is the skill that sets us apart from others. Artists are simply more visual by nature and are able to see things in unique ways. Our ability to create visual images out of perceptions or ideas has a definite kind of magical quality. If you refine this skill to a higher degree, it will help you sketch better and faster!

What Attracts Your Eye?

If you observe yourself or someone else sketching, you will see there is an actual procedure taking place. For the most part it's an unconscious act. You simply look at your subject for a moment, then down at your sketchbook page. You look up again—pause for a moment, studying your subject's features—then back down at your sketch. You glance up and down repeatedly. You don't think anything about this process, you just do it naturally.

But what are you actually *looking* at? What has attracted your eye? Can you replicate what you have seen on paper with just a few lines?

This process of looking at an object, studying its features for a few moments, then looking away and drawing its likeness is the same for every artist throughout time. It is simply the way we see and draw.

But seeing isn't enough. In order to draw better, you have to be able to not just see an object, but to recognize its essential characteristics well enough to re-create its likeness on paper with only a pencil. To sketch better you have to see and quickly recognize shapes, contours, basic features, details and relative values.

Create Sketches From Glances

Years ago, as I began to really get into this, I actually tested myself with a chronograph, a stopwatch with a second hand. I would glance at my watch for just a moment to see how brief a glimpse it would take for me to recognize what time it was. I discovered that under normal circumstances I could tell the time with a glance that lasted no more than a quarter of a second.

I have gone on to test this myself in a thousand different ways. I've determined that when people glance at something, no matter what, they are actually only spending less than half a second, and usually less than a quarter of a second, looking at the object. Yet a great deal of recognition takes place in this brief span of time.

The amount of visual information we recognize in a mere glance is phenomenal. The more alert and aware we are of these subtle momentary impressions in our minds, the more we have to focus on as we sketch. Anything that helps us become more mentally alert and aware can also help us sketch.

Recognition is more complex than *seeing*. Recognition is a higher brain function that involves many other features of consciousness in fractions of a second.

As artists, we live in these fractions of seconds. We have trained ourselves to see into these tiny moments in time, retaining the afterimages in our minds a bit longer than most people. Most people have no real need to retain most mental images very long. However, for artists, these images help us to draw.

Every Image Can Be Simplified

Under ordinary circumstances artists are encouraged to study their subjects carefully and intently, taking lots of time to really see their subjects. With my fast sketching method you must be able to glance at a subject and quickly capture something of its basic shape.

This photograph of my brother-in-law Jim and his dog, Boomer, has a lot of subtle detail that could easily slow you down. Your first task should be to capture the basic shapes with outlines. The key is to look for and see shapes rather than details. This skill will allow you to work effectively from live subjects in unposed settings or at light speed in your studio.

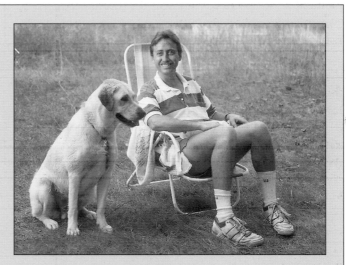

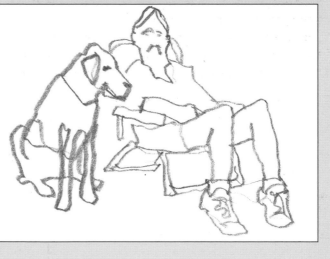

The image above took less than a minute, working from only two or three glances. The one to the right took a little over a minute, working from four or five glances. The idea is simple: How much visual memory can you retain from only a few glances at the subject?

To sketch faster, you need to see things more clearly and recognize shapes rapidly. You have to pay more attention to these *present-moment* mental images that are created in your mind through your eyes.

You look up at an object for a few moments. Then you look down at your sketchbook. As you are trying to draw its likeness, you have actually shifted your attention to the afterimage that is still retained in your mental vision. It fades and you glance back up at your subject, taking more and more of it in. You try to recognize familiar shapes in this object, for familiar shapes make it easier to draw. You see how these shapes combine to make up the whole object. Looking for those features of a subject that are most distinctive and drawing those first helps you refine your recognition skills.

Practice This Skill With Each Subject

I've used the same skill with each of the images below—a few moments studying the image looking for the simplest shapes and then fifteen seconds sketching.

Afterimage Skills

1 Intense observation
Look for some posture, movement or detail of your subject that can be rapidly sketched.

2 Afterimage vision
Look at, recognize and identify something in a mere moment, then retain its mental image long enough to sketch it.

3 Rapid sketch of afterimages
Draw that mental image with fast sketching style.

4 Selective observation and recognition skills
Focus your mind on a subject using selective criteria to the exclusion of other visual information. This is the same perceptual skill employed when spotting a loved one in a large crowd. Even from a distance, you somehow are able to identify that face in a sea of people.

5 Sketching of structural shapes
Try to see the structural shapes in a subject that make it easier to sketch. Every subject, no matter how complex, is actually made up of simpler shapes. By first recognizing, then sketching these components one after the other, you can build a complex structure and tie it all together with careful shading.

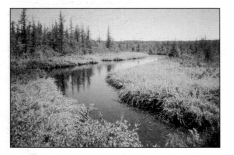

Let's begin simply. Here's a classic landscape with a nice composition. Look at the subject for a few moments. Study my sketch below. I isolated the most essential shapes of the riverbank, a few tree shapes and the far distant horizon using the simplest outline of their forms.

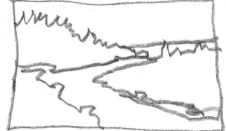

With only a glance or two you can capture a basic outline of very complicated shapes. Don't get caught up in the details. The sketch below was done in seconds with one continuous line outlining the shape.

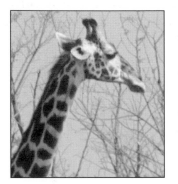

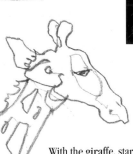

With the **giraffe**, start with its horns and continue around defining its entire head shape. Try this several times, leaving the spots for last.

Do Fast Outlines First

Even though these subjects are more complex, try to visualize the structures with very basic outline shapes. This should be your first imaging goal for any subject.

Study these photos briefly, then look away and sketch using your afterimage memory.

I recommend you use your 9B graphite pencil on smooth, semisoft drawing papers. See how easy it would be to add more detail once you've defined the shapes?

Afterimage Exercise

Read all of these instructions before turning the page.

> *Don't peek at the next pages until you're ready to sketch or you'll spoil the effect!*

1 Take your pencil in hand and prepare to draw, hand on your sketchbook page.

2 Turn the page quickly, and glance at the photographic image on the following right-hand page. Study its features and shapes quickly, spending no more than five to ten seconds looking at it.

3 Turn this page back again to hide the photo. Look down at your sketchbook while retaining the mental image of that object and quickly draw the most basic shapes you saw. After you draw what you can remember, put your sketch aside and take out another sheet of paper.

4 Now that you've had a brief look at the photo and tried to draw its likeness, this second attempt should provide you with better recognition of shapes and features. Here goes: Turn the page for another five to ten seconds.

5 Cover the page again. Do another sketch from your mental vision of the photo. Be sure your first sketch isn't visible so you aren't tempted to glance at it for reference. Rely totally on your afterimage awareness.

When you have completed your second attempt, turn the page and review your efforts on both attempts. Then study mine as well. **Follow the same procedure with the image on page 43.**

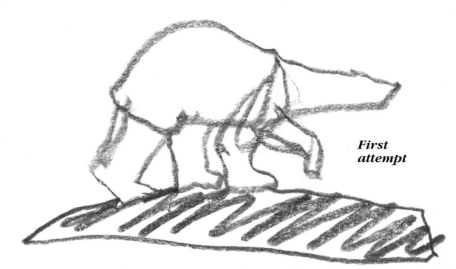

First attempt

Afterimage Exercise 1

First Attempt

Both my first and second sketches are shown at actual size. My first sketches of virtually any subject are usually small, often even smaller than this first attempt.

You can see from my first attempt at sketching this polar bear that I only captured the most essential shapes before I lost the mental image.

Second Attempt

The second sketch is bigger, and you can easily see that I was able to capture more detail in this attempt. On my second try, I sketched the large torso mass first. Then I added the neck and head shape. The front right leg was next, followed by the front uplifted leg and paw. Then the rear legs were added, beginning with the right back leg. I finished by adding the ruffed belly, the ear, eye and nose, and finally a rocklike shape underneath his feet.

This exercise shows you how much you can retain and sketch with only a few seconds of observation.

Now prepare for another exercise. When you are ready, turn the page for ten seconds of observation and give the next image a try.

1

2

3

4

5

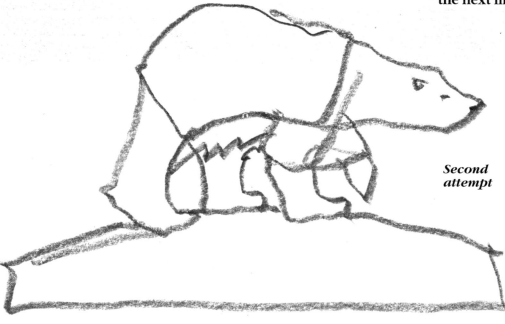

Second attempt

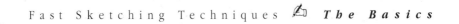

Afterimage Exercise 2

First Attempt

This image is tougher than the polar bear, in that it is more visually complicated with geometric and natural shapes, lighting effects and a far distant range of detail, including people. In this first attempt I was only able to capture the most elemental shapes, but no people, and not much detail in the lighthouse.

Second Attempt

The second time I was able to see the basic dark rock masses better, and my lighthouse details are a bit better.

You'll also notice how my first attempt is noticeably smaller than the second sketch. These images are actual sketchbook size. When you are working fast you simply cannot sketch big. You'll use too much time if you try to fill a sketchbook page with a fast sketch. Keep your first attempts small, loose and fast.

First attempt

Second attempt

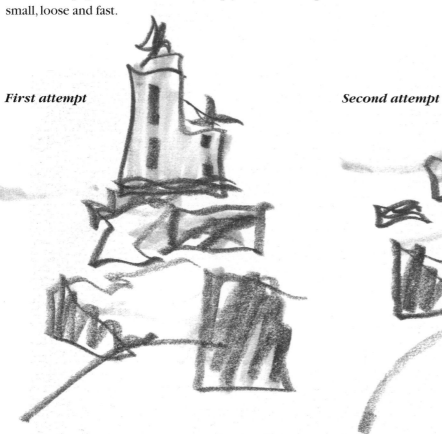

Sketching Sequence

I will go into this in greater detail later in the book, but note that these sketches were begun not with the lighthouse shape, but rather the dark rock shapes situated around it. This is why my lighthouse detail in the first attempt is so minimal: I was trying to capture the dark masses of the rocks.

In the second sketch I was able to clarify these shapes better and spend a few extra moments making mental note of the lighthouse details. Even so, the windows are not aligned correctly.

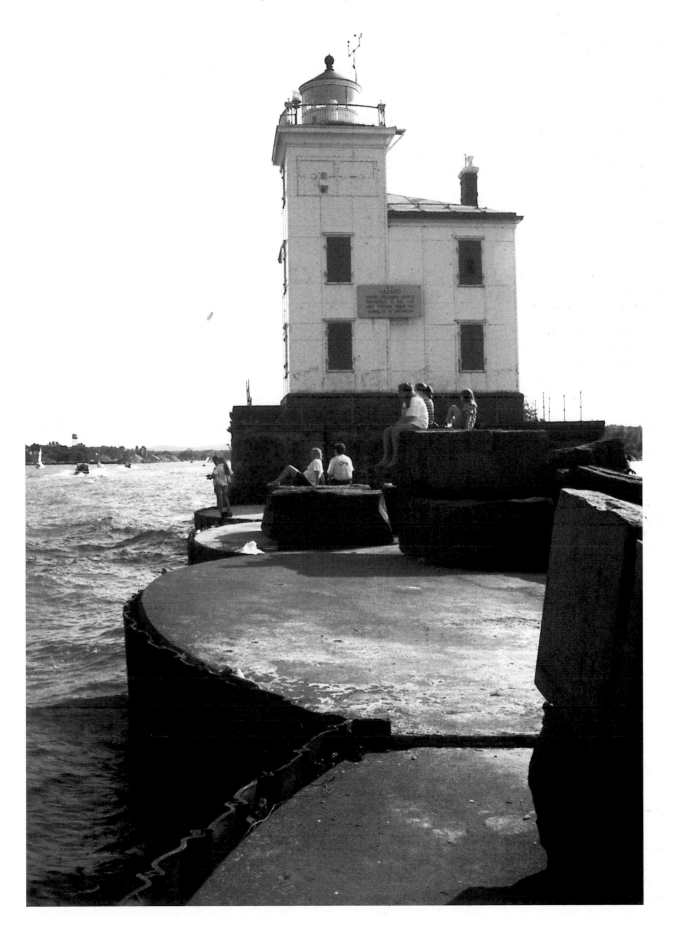

Chapter Two
Landscapes

My First Love

To be a wildlife artist today, you really have to be a great landscape painter. The top wildlife artists in the world could just as easily leave the birds and animals out of their paintings and still have wonderful works of art.

I started with landscapes but am actually better known for my watercolors of the birds and wildlife of India. However, it's the combination of my background as a landscape painter coupled with my ability to paint animals that has allowed me to compete at the highest levels in the world of wildlife art.

In fact, I consider myself a classic watercolor painter, rather than a strict wildlife artist. Watercolor painters have a long artistic tradition, dating back into the 1700s, of painting a wide range of subjects.

India inspired this wide range of artistic fascination in me. Today I sketch and paint people, birds, tigers, elephants, cows, cityscapes, landscapes, architecture—you name it. The reason for this diversity is

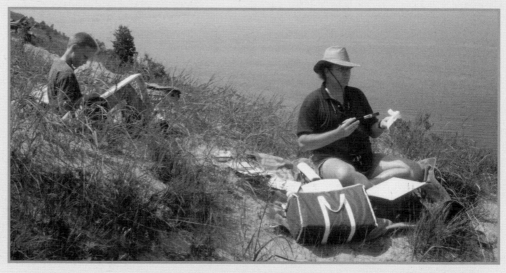

My nephew David and I sketching and painting at Empire Bluffs, Michigan.

simple: I am constantly looking for light in nature.

I am inspired and motivated by light. In all of my sketches, drawings, field studies and finished watercolors, I am constantly striving to capture some unusual or interesting quality of light.

The light can be a glint off the neck of a peacock, or a reflection off wet sand where the waves lap up onto a beach that fascinates me and inspires me to draw and paint. In this section I'll share my most creative sketching procedures that I use with landscape subjects.

Sketches preserve your feelings about a scene, while a camera records details.

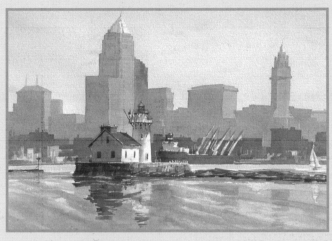

Suggestions

♦ **Sketch what attracts *you*.**

♦ **Omit 90 percent of the detail.**

♦ **Use three or four values tops.**

♦ **Sketch for mood.**

♦ **Work fast.**

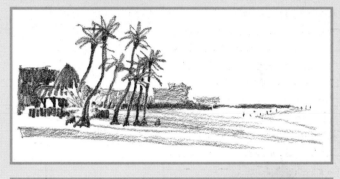

You can never draw or paint everything. You have to become creatively selective, looking for only those subjects that attract your artist eye. As you evaluate subjects, squint your eyes to omit most of the detail and see the design and values better. Look for and sketch only those elements of the landscape that are most essential, dramatic or important.

Limit your sketches to three or four values— black or a darkest dark, a medium dark gray, a light gray and white. *That's all.* Any more values than that and you'll be drawing, not sketching.

In my landscape sketches my primary aim is to create a mood of light, with as little graphite as possible. I work fast, and I'm constantly looking for ways to sketch an effect of light that I can re-create in watercolor later.

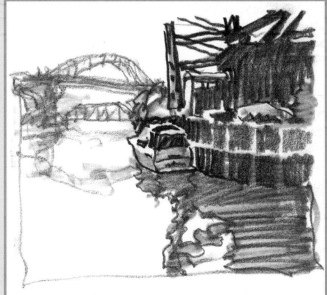

Top left: Elephants crossing a river at dawn in northern India.
Top: Downtown Cleveland's shoreline with lighthouse.
Middle: Estero Beach, north of Naples, in morning light.
Bottom: A cabin cruiser moored on the bend of the river, in the Flats of Cleveland, Ohio.

Sketches capture minutes. Photographs capture fractions of a second.

How can I develop painting ideas with sketches?

When you take a subject and translate it through a sketch, you can evaluate whether or not it would make a good painting idea.

This is what sketching is all about—reacting quickly to your environment and, in those few minutes, capturing something inherent and beautiful about being there. Then you can continue the development of the idea with quick watercolor sketches back in your studio.

One day I had to get out of the studio and sketch. I ended up exploring the old industrial area of Cleveland, which is now the entertainment area known as the Flats. It was cold and snowy, with periodic breaks in the clouds when brilliant sunlight would illuminate the landscape.

Sketching like this epitomizes one of the standard ways I work on landscapes. I immerse myself in a region and study the lighting at various times of the day and season. These two pages show my visual struggle to create a body of work centered on this area of Cleveland.

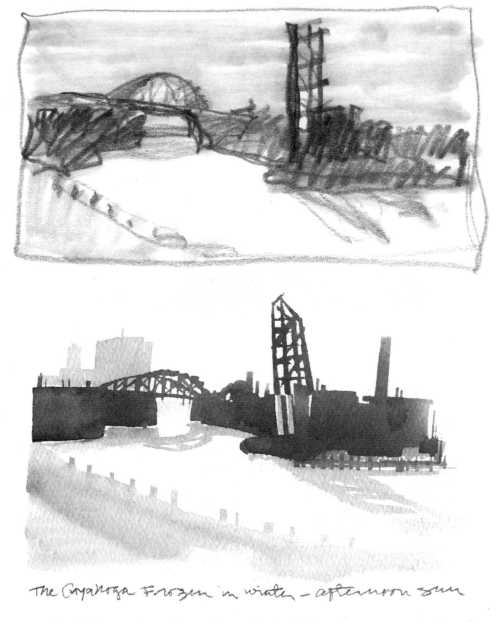

The Cuyahoga Frozen in winter – afternoon sun

I was captivated by this unusual scene of the Cuyahoga River, frozen and covered with deep snow. Can you see the strong, late-afternoon sunlight casting shadows across the snow-covered river? This would make a strong painting. The sketch at the top took only a couple minutes and captured the essence of the scene. When I got back to my studio and reviewed the day's sketches, I was again reminded of the intensity of the light in this scene. I quickly picked up my 1-inch wash brush and did a small Payne's Gray watercolor study (bottom) to test the idea further. I wanted the intensity of the light to be dominant, so I eliminated the clouds that were there when I sketched the scene. By omitting the clouds altogether I heightened the effect of intense, diffused sunlight illuminating the landscape and creating strong shapes out of the bridges and the drama of the shadows falling across deep snow on the frozen river.

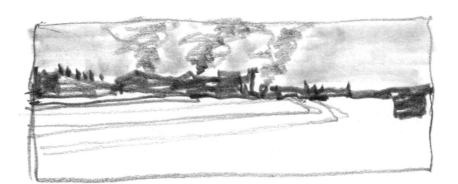

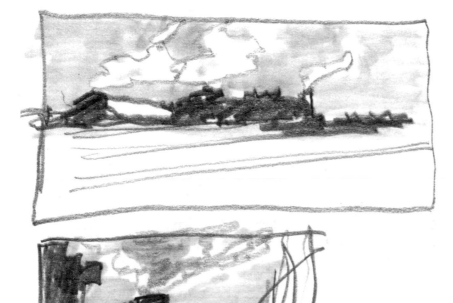

Visual Variety

The very idea of going out with your sketchbook, pencils and camera may seem old-fashioned to some. With the wealth of imagery at your disposal these days, an artist might never have to leave the comforts of the studio, let alone set off for far-off distant lands.

Many artists don't travel much. If they do, they don't travel for artistic inspiration and field work. So what is it that drives those who do?

For me the answer is simple: I thrive on the visual variety and stimulation that travel presents to my artistic nature. I constantly keep my eyes open for new or unusual subjects. But you don't have to travel to Asia to find inspiration. I also sketch and paint my hometown.

Sketch what catches your eye. The brilliant sunlight coming through large plumes of steam rising into the dazzling clear sky captured my attention right away, resulting in the top two sketches on the left. The intense sunlight was blinding as it reflected off a new fallen blanket of snow.

No matter where you are, there is variety. Open your artist eyes, look around you and start sketching.

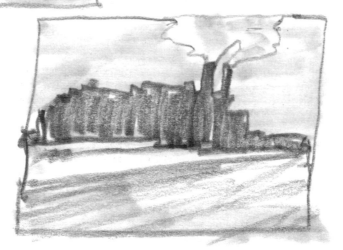

How can I create visual depth and mood in my sketches?

Varying your pencil pressures is one way to create a sense of visual depth. That alone can create mood in a sketch. The mood is a direct result of the relative gray values in different parts of the sketch. This is achieved by pressing harder or lighter on some parts of a sketch. The sketches on these two pages show you this effect.

When I sketched the sailboat tied up along the Cuyahoga, the air was hazy and humid. The haze grayed out the bridge in a foglike manner, which was very appealing.

I started by drawing the boat with a fairly strong pressure, creating the darkest dark in the image. Once the darks are established it is quite simple to ease up on the rest, building drama and mood into a five-to-ten-minute sketch.

This is an extremely easy visual effect to create, if you learn how to control your pencil pressures.

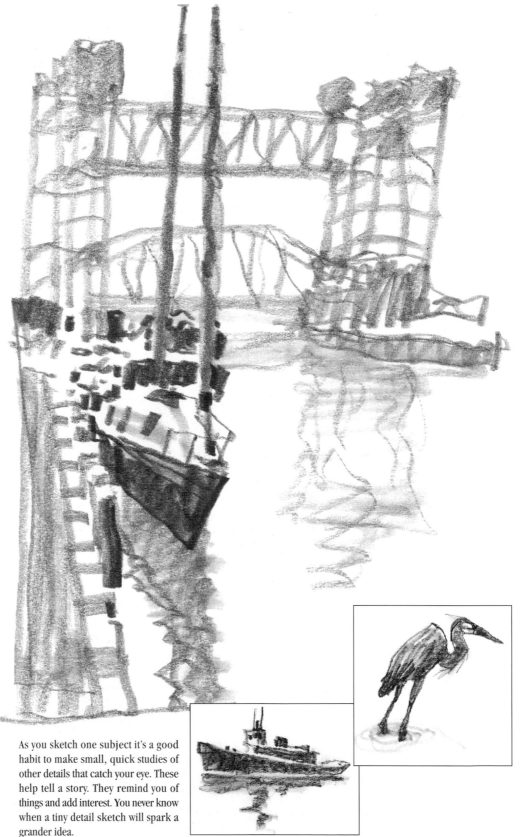

As you sketch one subject it's a good habit to make small, quick studies of other details that catch your eye. These help tell a story. They remind you of things and add interest. You never know when a tiny detail sketch will spark a grander idea.

More than 50 percent of these sketches were done with the blending tool itself. It's the subtle gray tones made with this tool that establish the mood.

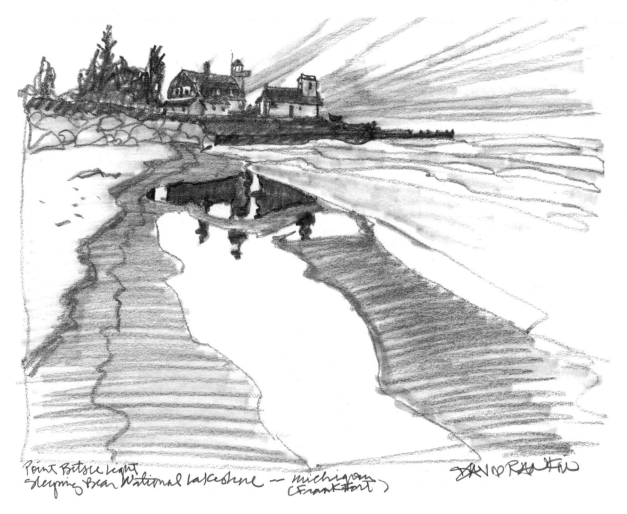

Right: The Hunting Island Lighthouse near Fripp Island, South Carolina.
Below: The Point Betsie Lighthouse just north of Frankfort, Michigan.

Think Through Painting Ideas While Sketching

Deciding what to draw and paint is a never-ending process. For many artists, choosing what to *paint* is the hardest part of the process. This is a good reason to sketch. It's in the sketching of any subject that you develop clarity regarding that subject.

You must develop the ability to think through your painting ideas in a sketch. Don't settle too soon on a subject or design that may lack visual interest. It will improve your painting if you spend more time exploring ideas in sketches. The better and faster you sketch, the more ideas you can experiment with.

Paint less and sketch more. You'll improve your paintings because you will have visually explored the subject intensely in graphite before ever lifting a brush. By sketching more you'll realize quickly that every image doesn't deserve to be immortalized in a painting. In some cases I never take a subject on to a finished painting because I don't feel I can create anything better than my original sketch.

What is it about a scene that catches your eye? Don't start sketching unless you can answer this question. When you do come up with an answer, build your sketch making sure you capture the essence of the answer you came up with.

After you've completed a sketch or two of your subject, ask yourself a harder question: If I were to paint this image, would anyone else find anything to like in this subject, design or idea? If you're not sure, maybe you should look further for suitable subjects.

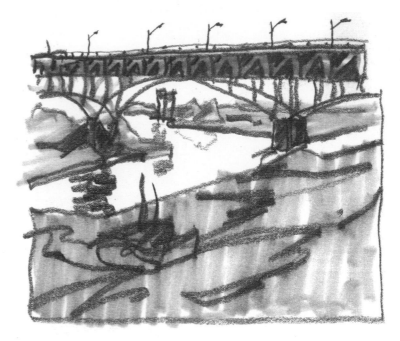

In each of these sketches it is the relative gray values that make the sketch and give it life and mood. Note how I've created both of them with only three values—a darkest dark, a midvalue gray and the white of the paper.

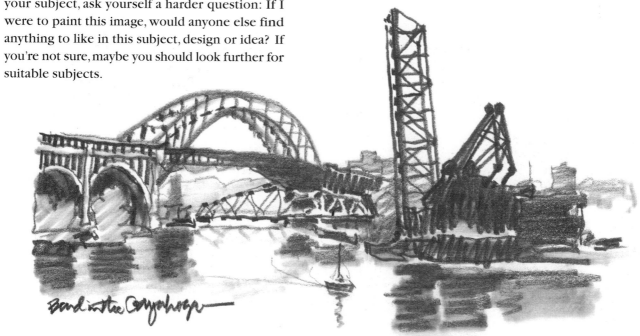

50

These sketches took more than a few minutes to sketch. A couple of them took fifteen to twenty-five minutes, but I still think of them as sketches because I was in fact working very fast. Landscape subjects like these don't move, so I'm not in such a hurry to get something sketched as I am with both people and animals.

This is why my landscapes tend to be bigger than my people or animal sketches. Also, I can include more detail, spend more time on carefully delineated shapes, and take more care in developing just the right value in various parts of the sketch. If you look carefully you'll see it's these carefully crafted values that create dimension and mood.

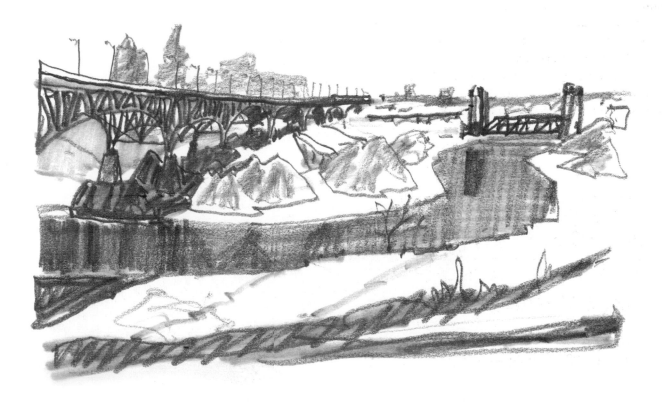

Take Your Sketchbooks on Vacation

Notice how important the blending tool is in the landscape sketching throughout this entire section. Not only does it provide you with a way to create the right shade value over the pencil lines, but it can also be used just like a pencil. That's how I created the light gray image of the far-off condo in the sketch below.

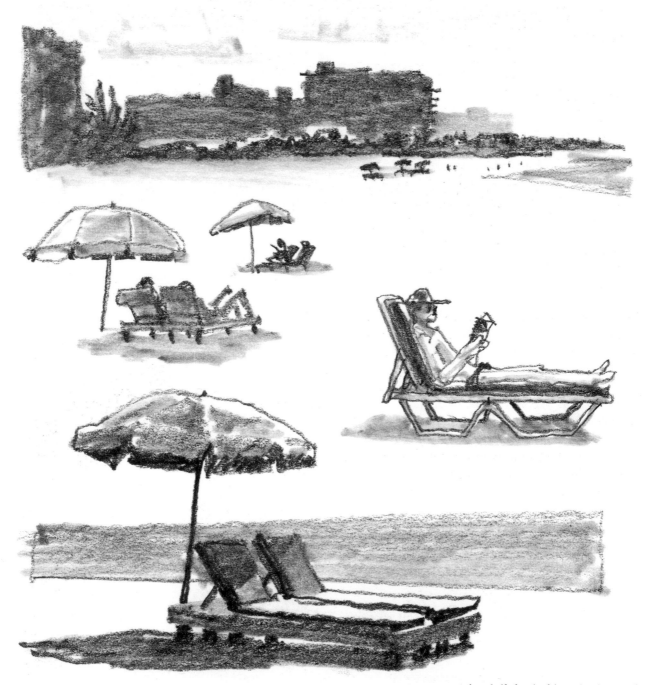

At least half of each of these sketches was done with the blending tool rather than a pencil. Once you get used to using it in this fashion, you'll wonder how you ever got along without it.

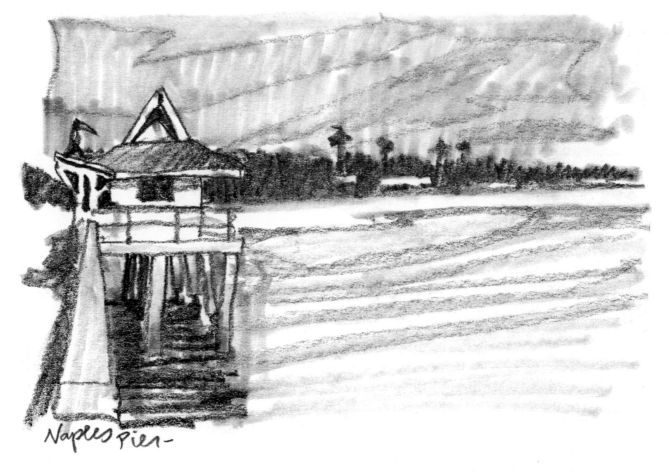

Naples Pier -

Use Blending Tool to Create a Watercolor Wash Effect

The sketch above is a view of the shore from the Naples Pier in Florida. The others are from the Fort Myers Beach Pier. Switch to the blending tool to delineate sky values, cloud formations and drama. The blending tool creates a soft, fuzzy gray line, or an allover, soft gray value much like a light watercolor wash. As mentioned previously, the linework establishes the shapes and details, but the shading provides the magic. Can you visualize these sketches without the blending tool's ability to create various midvalue grays? It's the finishing touch.

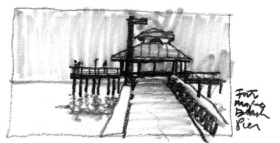

Fort myers Beach Pier

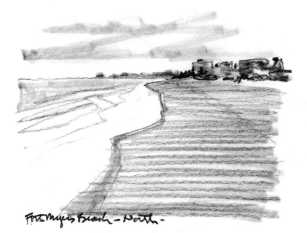

Fort Myers Beach - North -

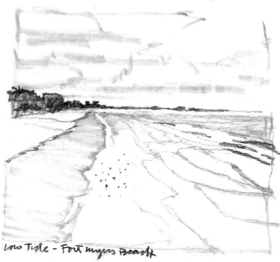

Low Tide - Fort myers Beach

This fifteen-minute watercolor study of a desert landscape allowed me to establish a value relationship more completely than graphite.

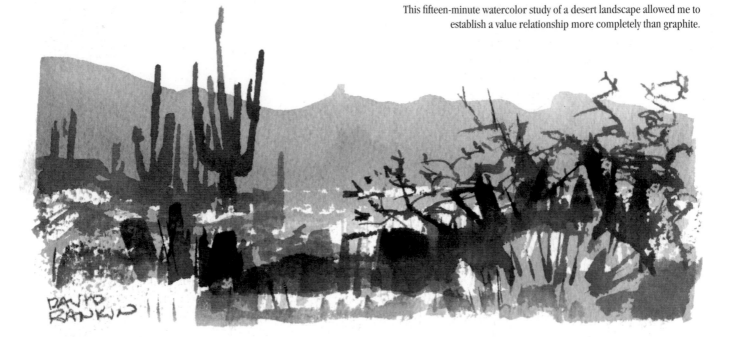

When I'm working in the field, I'll often indicate where the sun was when I sketched the subject to establish the correct light source in the shadows.

From Graphite Sketch to Watercolor Study

Here are two different sketching techniques. Can you see how similar my graphite sketching style is to my watercolor sketching style?

Both of these are studies, but the one at right is done with a graphite pencil, while the one above is done in watercolor working on Arches 140-lb. (300gsm) rough watercolor paper.

When sketching in both mediums, you should begin with several graphite sketches, then switch to watercolor when you want to carry an idea further. In either medium, keep the values and light source in mind. Remember that when you're building a landscape in graphite, just as in watercolor, you should plan for and leave the whites white.

As you sketch a subject, visualize elements as you would paint them. In this way, you think out a painting with a pencil first. As you get better at sketching you will actually begin to see your subjects differently. You'll see an idea in a landscape—a color, design or texture—and try to replicate that visual element in graphite so it reminds you of something when you try to paint it later.

Linework creates the overall design composition, and the shading provides the emotion and the mood.

The image below is a small full-color watercolor study, done after a day's sketching expedition in Ventana Canyon. You can see how the ideas I developed on-site in my sketches at right carried over into my watercolor sketch.

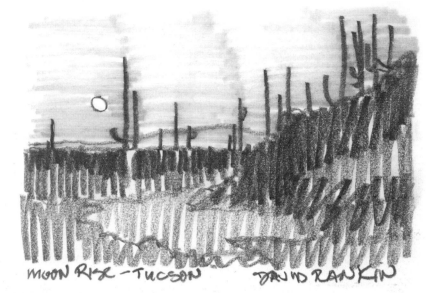

MOON RISE – TUCSON DAVID RANKIN

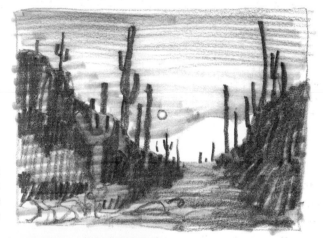

Several years ago my wife and I made our first trip to the Southwest. I fell in love with the colors and moods of the desert, with its stark and dramatic quality of light. You can see from these sketches that it doesn't take much to indicate the drama of the desert—mostly, it's in the shading values. The exotic silhouettes of the giant saguaro cactus around Tucson create dramatic landscapes at virtually any time of day.

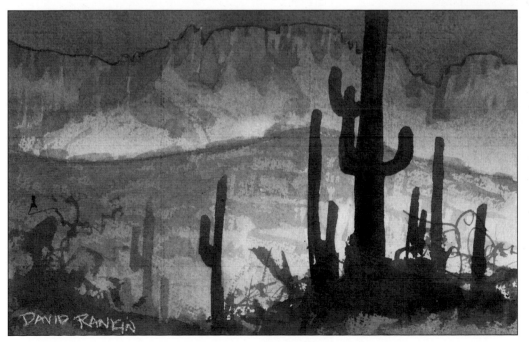

DAVID RANKIN

Technique Exercises: Sketching From Photo Reference

The goal of these exercises is to begin to work directly from photographic reference images to build up your technique and speed.

Most of my professional artist friends are excellent photographers. I recommend that if you are not presently proficient at using a 35mm camera, you should become so as soon as possible. The purpose of using photography is to back up your sketches with photographic images that will provide you with visual detail you can refer to back in your studio.

Photographing birds in South India.

On the next three pages we're going to sketch from photographs in order to practice technique and build up your sketching speed. You'll be working with some of my slide images alongside my sketches, with comments on how I put together the compositions for each.

I use my sketching procedures both in the field and in the studio.

Field Work I sketch in the field, doing watercolor studies on location and taking backup slides of locations, lighting effects, compositions and details. All of these specific creative endeavors make up my initial efforts to seek out and identify suitable subjects for my paintings.

Studio Work The second procedure is my creative ideation in my studio. My field studies and sketches form the bedrock of my creative process. These efforts are supported by my

Sketching and painting landscapes along Lake Erie.

photographic work, capturing detail and fleeting moments or lighting on film. Once in my studio with all this visual material, I again use fast sketching procedures to help me think through, organize and creatively try out painting ideas.

Although I slow down a bit when working with my slides, field sketches and watercolor studies in the studio, I still work extremely fast developing painting ideas. This training will help you speed up your technique dramatically. Remember, at this point it really doesn't matter what you sketch; what matters most is trying to see and sketch faster.

Sketching from photographic reference in the studio can actually speed up your ability and allow you to work better out in the field.

How can I improve my compositions?

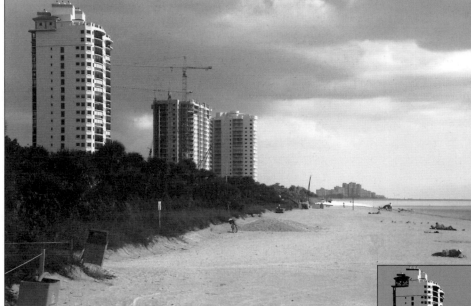

Look for the Whites

Throughout this section I've created numerous computerized value studies, like the one below, to help you see and sketch correct gray values. When evaluating any image, especially in the sketching stage, in which you are only working with three or four values, it's good practice to look for and design the whites because it's the whites that direct the eye.

Here is what may at first seem like a complicated subject. But if you study my on-site sketch (below) and the value study (right) you'll notice how I selected only the most basic shapes to sketch and enhanced the white angular cloud line. This improves the composition. Also notice how close my field sketch is to the value study—grays with black defining the whites.

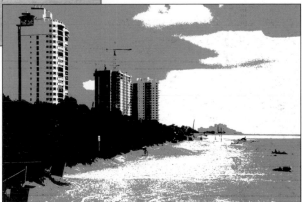

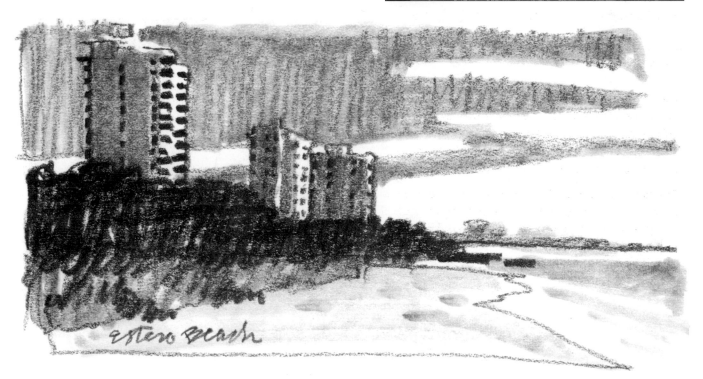

estero Beach

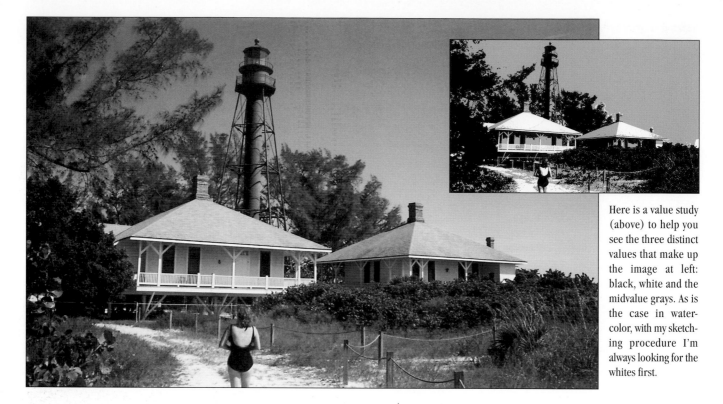

Here is a value study (above) to help you see the three distinct values that make up the image at left: black, white and the midvalue grays. As is the case in watercolor, with my sketching procedure I'm always looking for the whites first.

Sanibel Lighthouse

It was almost noon when my wife and I arrived at the Sanibel Lighthouse. You can usually tell the time of day by the angle of shadows. The sand was very hot, so I was sketching quickly. You can see I didn't spend any time detailing the rungs in the railing or the fence posts. In fact, I worked so fast that I overlooked the distinctive roof supports altogether.

This is the kind of visual detail best left to your 35mm photographic backup. In this case these buildings are pretty simple in shape. If it hadn't been so hot on my feet and I had been sketching a bit slower, I'm sure I would have noticed the roof supports and at least indicated their shapes.

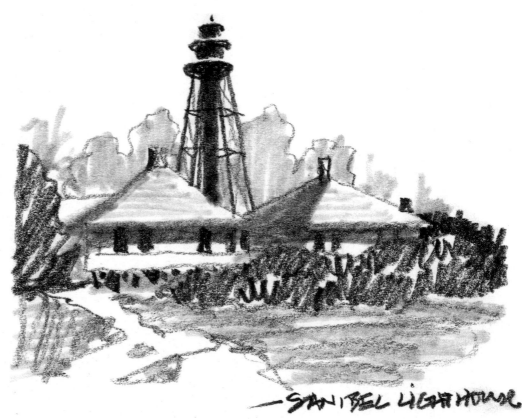

San Carlos Pass

Just south of Estero Beach, heading toward Naples, I spotted a cutoff that allowed me to drive out and get an interesting view. What caught my eye was the gentle curves of the causeway etched brilliant white against the azure Florida sky.

Here I sketched the bridge first, then the buildings. Then I laid down some horizontal lines in the water and shaded them with the blending tool. Notice how the sky was done with the blending tool alone. This gray tone enhances the whiteness of the bridge and buildings. After the sky was done, I rapidly indicated the Australian pine limb.

My sketch is very similar to the value study at right. Notice how two midvalue grays, a dark tone and white clearly delineate the scene. This is what you should try to achieve in a rapid sketch done on location or in the studio.

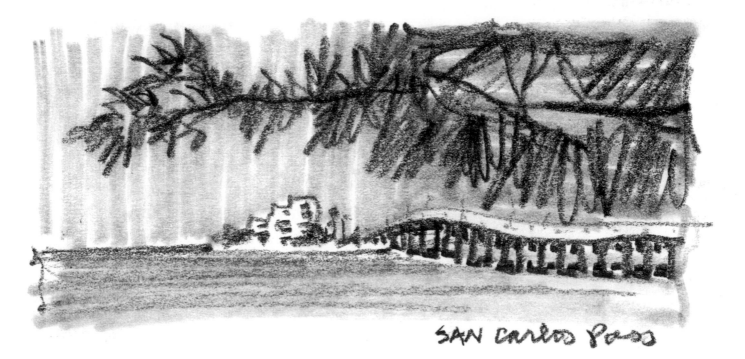

SAN carlos Pass

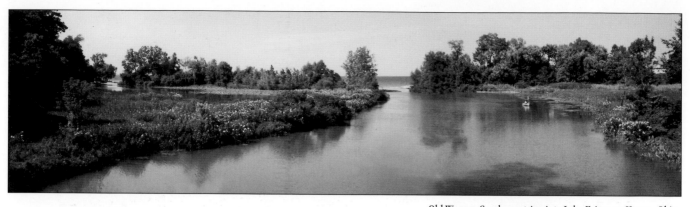

Old Woman Creek emptying into Lake Erie near Huron, Ohio.

Simplify Values

When sketching complicated land-scapes like this one, it will help a great deal if you target the major design elements and force everything into three values.

This landscape image contains the major elements of sky, water and land. But when I did these sketches, there was a tremendous variety of greens in the foliage—gray-greens, yellow-greens, blue-greens, blackish greens and reddish greens.

It had stormed the night before, so the river water emptying into Lake Erie was silted and murky brown. The sky was light and clear with only a wisp or two of clouds, and there were various lilies and water plants in full summer bloom interspersed throughout the estuary.

When you first study a scene like this, try to eliminate the visual detail and simplify the diversity of values. Squint your eyes at these images and you'll instantly see the overall dark and light design elements, without all the detail. Squinting essentially allows you to view the subject in only two values—dark and light.

The best thing to do is a quick sketch, where you redesign the scene on paper into a darkest dark, the white of the paper and a midvalue gray. I did this in the first smaller sketch. In the second sketch I developed a bit more detail, and added a light gray to the sky and water to see how I could direct the eye toward the horizon. Then I backed up my sketches with several 35mm slides.

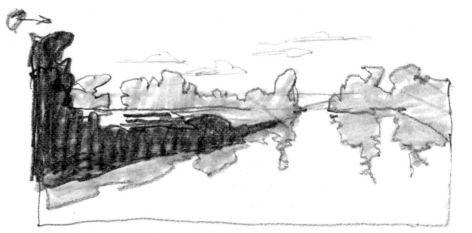

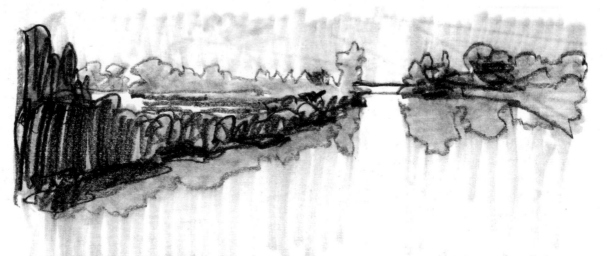

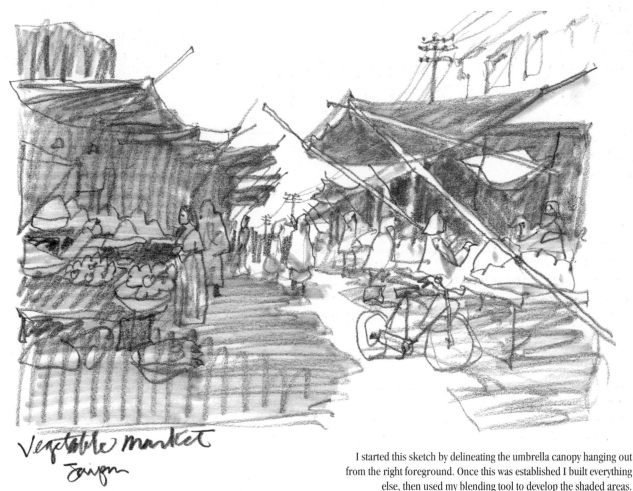

Vegetable Market
Jaipur

I started this sketch by delineating the umbrella canopy hanging out from the right foreground. Once this was established I built everything else, then used my blending tool to develop the shaded areas.

Develop Ideas Now

These two sketches were done on location in India in about fifteen minutes each. I'll always take backup slides of scenes like these, but it's my on-the-spot sketching that allows me to evaluate a subject for painting worthiness. If I only take slides, I waste the opportunity to relate to my subject directly, in the moment, in this particular light and mood.

When you sketch, don't be afraid to make lots of adjustments. Leave things out, adjust values, shift points of view and establish the correct values. A sketch embeds a subject into your mind in a way that photos simply don't.

The sketch to the right shows the Queen's Courtyard in the old Udaipur City Palace. The ancient tree caught my eye, so I did it first. Then I added the background, etching out its form with darker shapes, and lastly shaded just the right value into the shadows.

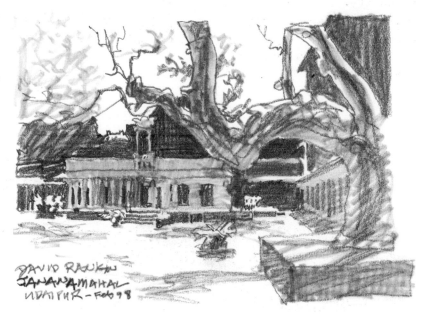

DAVID RANKIN
JANANAMAHAL
UDAIPUR – Feb 98

Sketch With Watercolor Eyes

If you look through each sketch in this landscape section, you'll notice that the whites are extremely important to the success of the sketch.

As a professional watercolor painter, it is second nature for me to evaluate a subject's design elements by looking for the whites. This of course is because with transparent watercolor, we don't use white paint.

When sketching you actually have to work in the same fashion. If you develop the visual habit of identifying the lightest portion of a subject first and then the darkest portion, it will make sketching much easier. Why? Because once you know where to retain your whites, you can help identify those whites with your midvalue grays.

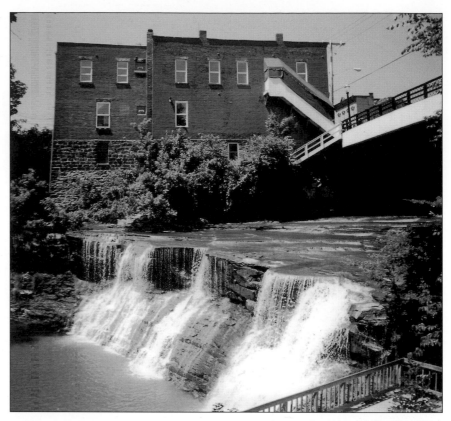

Chagrin Falls, just outside Cleveland, Ohio.

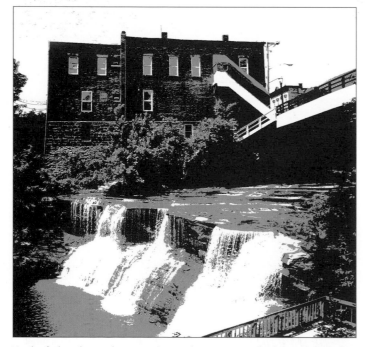

To clarify the values in this image, I created a computerized value study limited to only three values: gray, black and white. Your sketch should try to capture these essentials fast.

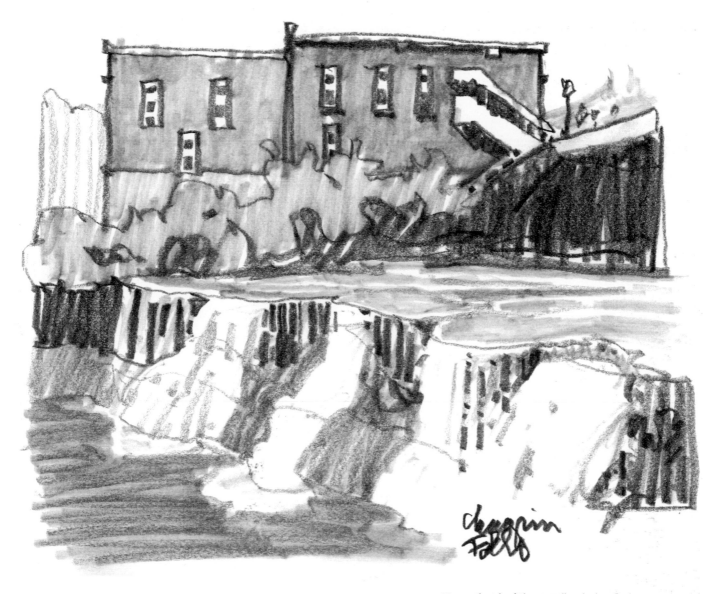

My pencil study of Chagrin Falls, which took about ten minutes.

Attract the Eye With White

If you look at the reference photo on the previous page, where does your eye go first? The falls.

This is because of the power of white to draw the eye. I chose this image to illustrate this most elemental aspect of good landscape work.

The image is actually very gray, with some blacks providing structure and detail. It's the white area of the falls that not only catches our eye but creates the visual drama in the scene. Once you recognize this fact you need to remember it as you build a sketch.

If you forget, you'll more than likely alter your values, and before you know it, the dramatic effect of these white falls surrounded by grays and blacks loses its visual impact. Plan for and preserve these whites in order to actually enhance this aesthetic element.

Should I use watercolor on location as well?

Training Your Eye

Constantly look at the world around you with what I refer to as *watercolor eyes*. See and evaluate subjects mentally throughout the day. See something and instantly go through, in your mind, how you would re-create that image with watercolor and brushwork. If you study my sketch at left you'll see how it nails down values and structure. Working on location allows you to think through and evaluate subjects quickly.

I knew within a few minutes that I would eventually paint this subject in this light, from this angle. After I finished my sketch, I took some photographs for backup reference so that I could refine the detail later.

When doing field work, you can't sketch and photograph everything. You have to make solid decisions and select subjects judiciously. It is better to come back with at least a few things that are workable and substantial.

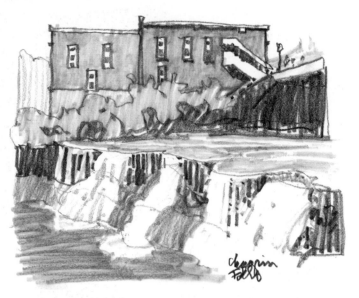

My favorite watercolor brushes are a Steve Quiller 1-inch (25mm) wash brush by Richeson Professional #7010, Winsor & Newton ½-inch (12mm) and ¼-inch (6mm) brushes, and a sable rigger.

How Would You Start a Sketch Like This?

I suggest starting with the dark verticals of the falls, and working from left to right. Always begin with the most distinctive features of your subject. I proceeded to delineate the lower parts of the falls, then quickly outlined the shape of the foliage and established the darkest part to the right under the bridge. Lastly, I added the building. But note that it is the shading that brings this sketch to life, as it allows me to establish the whites definitively.

If you look closely at this sketch, you'll see that I try not to overwork the linework. The face of the falls, where I've defined narrow columns of water spilling over the edge, is created with individual dark pencil lines, drawn with a fairly strong pressure to lay down a decent value of black with one stroke—not three or five.

This is easy to do with a 9B graphite pencil. By varying the pressures you can draw a heavy dark line and immediately switch to a light line. After you work with it a bit, the point gets flattened on one or two sides, allowing you to create a dark wide line or draw on its edge to make a thinner line.

Look at the surface of the water as it approaches the spillover edge. All of this gray shading was drawn with the blending tool itself, no pencil. The quick shading of the building, trees, the far distant buildings at upper right, as well as the face of the falls and the water below were all done with the blending tool.

> **Field Tip** When traveling to do your sketching, keep your field equipment to a minimum. I use Arches 140-lb. (300gsm) rough watercolor paper for watercolor field studies. If I'm only planning to sketch, then I'll only take a sketchbook, a thin box of pencils and my small Minolta 35mm pocket camera. If your field procedures are too cumbersome, you'll get tired of the hassles and quit going out. Remember, this should be fun!

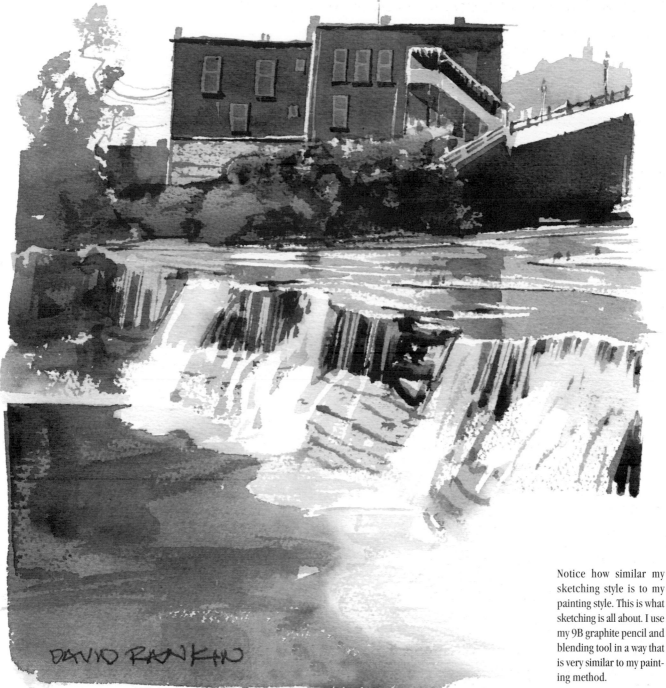

Notice how similar my sketching style is to my painting style. This is what sketching is all about. I use my 9B graphite pencil and blending tool in a way that is very similar to my painting method.

Payne's Gray Studies

After I've studied a subject on location, evaluated it, sketched it and photographed it, if I can, I will also do a watercolor field study on the spot. If I don't have the time, I have all I'll need back in the studio.

My favorite method is to do fast, small watercolors like the one shown here, using only Payne's Gray. For me, this a very natural progression from my graphite sketches.

Sketching procedures lead to watercolor studies, and this leads directly to finished watercolors. If you have time you can do a full-color watercolor study of a subject on location, once you've made all of your mistakes in your sketches and Payne's Gray studies. You may be thinking that this is too many studies, but the planning pays off.

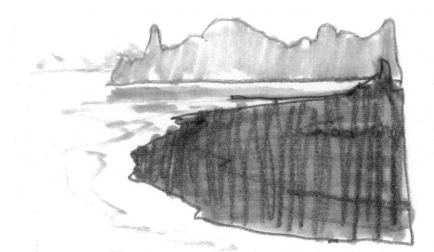

1 First graphite sketch (two to three minutes)

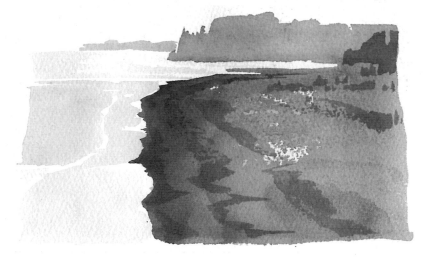

2 First watercolor sketch (five minutes)

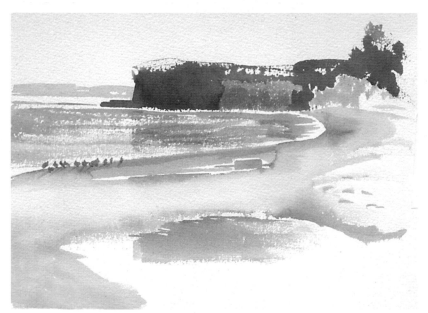

3 Second watercolor sketch (fifteen minutes)

Working Fast on Location

Field work should flow quickly from one stage to the next, especially if you are trying to capture unique lighting effects.

Here I was working on the beach, at the point where Old Woman Creek empties into Lake Erie. It was about 10 A.M. In less than two and a half hours I did everything on these two pages, facing east into the sun and then facing west with the sun at my back.

1 This is the initial sketch of the shoreline, which took about two or three minutes to complete. The intense morning sun grayed out all the intensity in the colors, yielding a strong design. I simply outlined the basic shapes, scumbled in some rapid linework and used my blending tool to shade and complete most of the sketch.

2 Once I've done some initial visualization sketches in graphite, I'll often switch to watercolor blocks for some equally fast watercolor sketches. For this watercolor sketch, I used a 1-inch (25mm), sharp-edged wash brush and Winsor & Newton Payne's Gray for everything. There is no preliminary drawing of anything, allowing me to work fast and nail down the values with little or no thought to detail.

3 Once I've done an initial graphite sketch and an initial watercolor sketch, I do another Payne's Gray watercolor study, a bit larger than the first. By now I've developed a feel for my subject with the previous sketches. And as you can see, I moved my position to include this tiny inlet of the creek, adding more interest to the foreground composition.

This study took fifteen minutes or so and allowed me to focus on certain details, such as the reflections in the foreground water, the reflected sunlight off the lake and the relative value of the midground tree line.

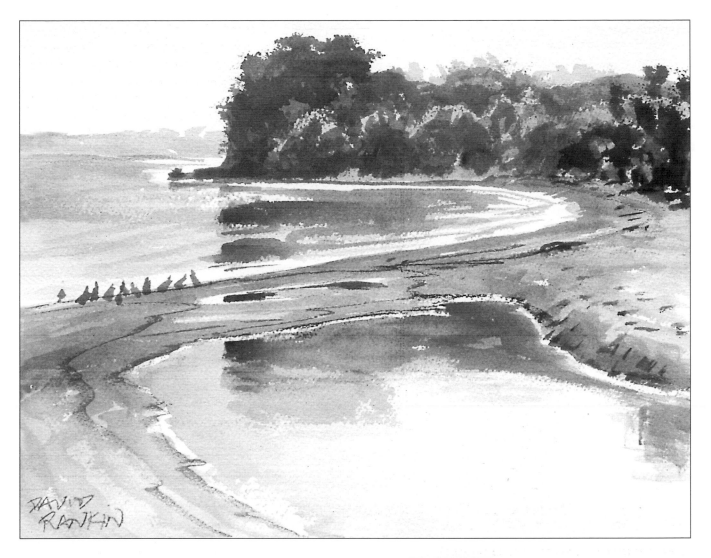

Working Both Directions

The finished watercolor above is what I call a full-color field study. Since I don't have the luxury of using a hair dryer to speed up the drying process when working in remote locations, I typically have several watercolor studies going at once.

While waiting for the painting to dry enough to proceed, I'd simply turned around and worked on the other, shown at right. I hate waiting for a wash to dry, so in this way I compensate for the slow drying time. You can be very productive in your field work if you work in this way.

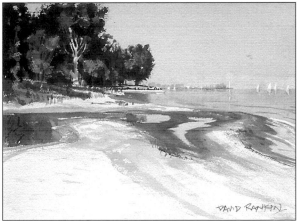

Both field studies on this page were done in full color in about forty-five minutes each, facing opposite directions.

Keep It Simple

No matter where you are, the idea is the same—
simplify complex images to simple shapes.

Notice in the sketch at left how the basic shapes are outlined and then filled in by shading over the lightly scumbled lines. Without the blending tool you can use your fingertip, but with the tool you can actually draw and shade in tiny areas accurately.

Later that day I did another sketch of the Taj Mahal, seen below, when the light was coming from the west. The finished watercolor on the bottom of the next page was developed from these sketches.

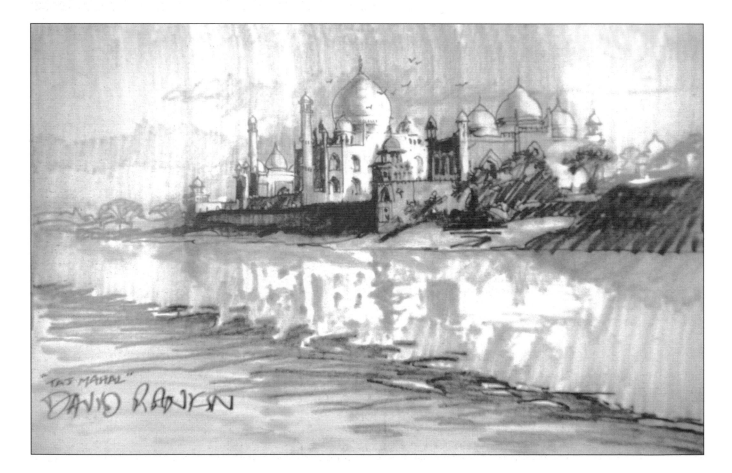

I loved this light enough to come back the next morning with my watercolors. I started with the small watercolor study at right, trying to capture some of the dramatic quality of light. The study took about fifteen minutes and was done without preparatory drawing. I used a 1-inch (25mm) wash brush and a very limited palette of Payne's Gray and New Gamboge Yellow. This combination of cool grays and hot earthy yellows does justice to a hot summer morning in India.

Working fast with a very limited palette forces you to stay loose, look for precise shapes and firmly establish your values. Remember, no matter what the subject, try to sketch and paint mood.

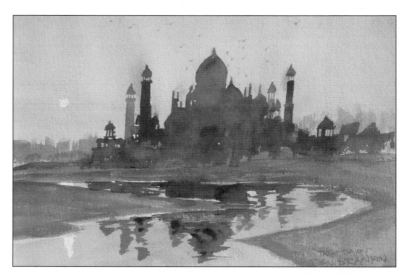

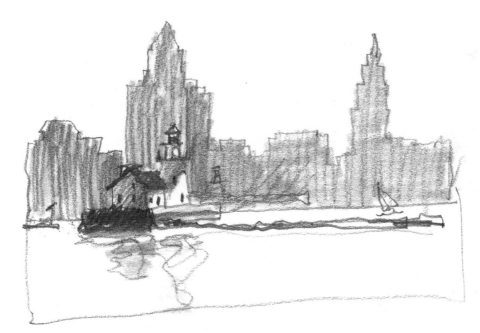

I'm always looking for unusual lighting and compositions. The sketch to the left and the painting below show the Cleveland skyline looming up behind the lighthouse. This was sketched from a tourist boat while the one on the opposite page was sketched from the very end of a pylon breakwall, looking back in at the Fairport Harbor lighthouse just east of Cleveland.

You can see in both instances how close my field thinking and sketching is to the finished paintings. Both paintings were three-hour painting demos done in some of my recent watercolor workshops.

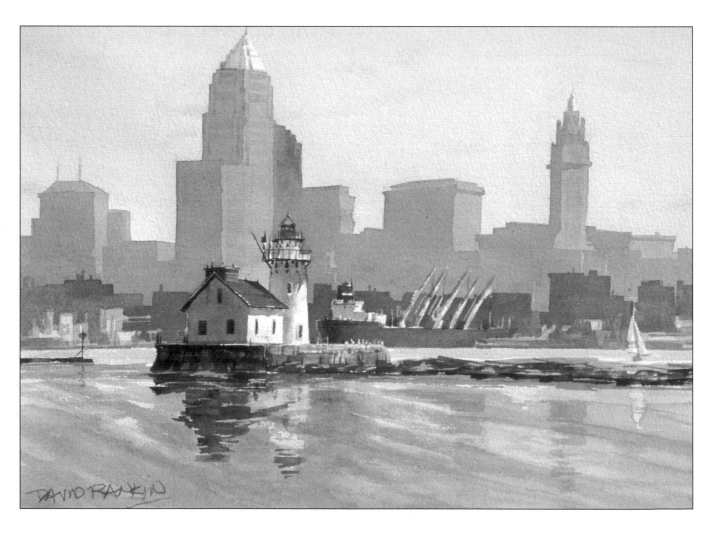

Light is the dominant factor in all landscape work. In this instance I had driven to Fairport Harbor to sketch and paint the lighthouse that guards the opening into the Grand River. A summer thunderstorm had just blown through and provided a dramatic quality of light to the whole scene. The painting below shows the sky and light an hour later.

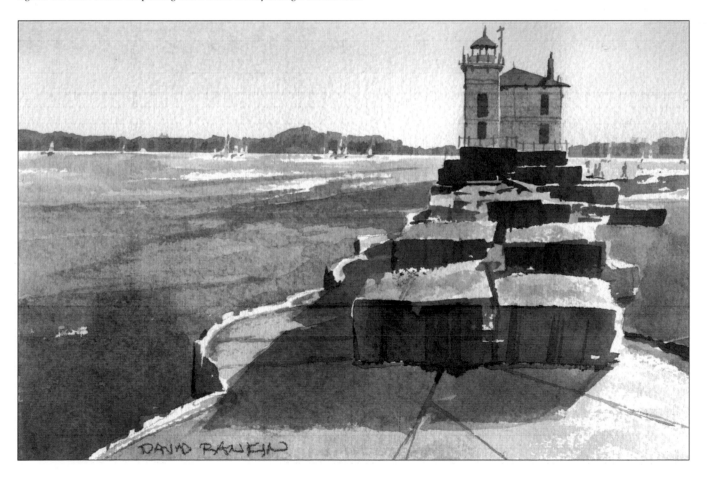

How can I maximize my productivity on location?

As you travel and sketch you may have a number of visual themes working. There is so much to see that if you're not selective, it wears you out. For instance, if I'm sketching architecture in Rome, I look for and sketch architecture. I try not to get distracted by or spend much time sketching other subjects. If something off-focus presents itself while you're working, photograph it quickly to make a visual record of it for later, but don't break the flow of what you're trying to accomplish. You'll be amazed at how much more productive your days will be when you learn to stay focused.

Piazza del Popolo
This sketch took about five minutes.

No Matter What the Subject, Initial Sketches Should Always Be Done Fast!
Since sculpture doesn't move there is a tendency to slow down. As soon as you do you'll start noodling details far too much. Work fast, outlining shapes and building a completed sketch quickly. You can do a slower, more detailed drawing afterward.

Moses and The Pieta in Saint Peter's, The Vatican
These sketches took about ten minutes each.

Leave the People for Last

Just as I recommend that you leave the spots until last when sketching birds and animals, the same concept applies when sketching landscape and architecture. Leave the details or people until last. Literally omit all the people and focus on the structures. Remember to simplify everything to basic shapes and shadows.

1 While sketching in the Piazza Navona, in afternoon light, I started with this dramatic fountain structure. I began with the head of the tallest figure in the fountain. I worked down and to the right, then straight across to the left side, and back up to the central figure. I've dropped out most of the shading here to show you what this looked like before working with my blending tool.

2 After I developed the various structures of the buildings behind and to the right end of the piazza, I then pressed down rather firmly with the blending tool so that the building shadows darkened. This helped to etch out the shapes of the white fountain statues, bringing them forward. I had to work fast because as the sun moves it changes the very dramatic shadows, and definition of the structures becomes more difficult to figure out and sketch.

Notice in this sketch how important the shading is. It provides the quality of depth and the light source.

Piazza Navona
This sketch took about ten to fifteen minutes.

Simple Linework and Shadows for Complex Structures

When sketching complex architectural structures, define the outlines of the buildings first, then use shadows to help define the structure by creating a light source without much detail. Notice how the rapid shading with a blending tool suddenly brings the sketch below to life. I've erased most of the shading in the initial steps to show you the development of the linework.

1 I started with the roof shape and statues on the top left side of the structure, working across and down until I had established most of the building. The many pillars are indicated with only a few vertical lines, drawn rather dark.

2 Next I sketched the decorative trees to provide a visual element all across the bottom, keeping the viewer's eye on the structure itself.

3 Finally, I added the remaining distinctive roof statues and flagpoles. The shading, as shown in the completed sketch below, not only creates a strong light source, but also helps define the structure. To add even more drama to the lighting, I could have added a darker value sky that would make the white marble building really pop.

Rome's Monument to Victor-Emmanuel II
This sketch took about five minutes.

When working fast it's essential to go after the most distinguishing characteristics of your image first. In this example of a gondola, it's the long narrow shape, with very distinctive shapes on both ends. If you get it wrong, start over.

1

2

3

4

Note I used just the tip of my blending tool to carefully shade in the back of the gondola, leaving a thin white line above the pole. This helps to create the illusion of light source.

5

1 I began on the left side, quickly sketching in the long bow shapes.

2 Next I delineated the other side of the gondola, working upward from the bow.

3 Once I had the essential shape of the gondola, I then added the gondolier standing in a distinctive posture. This much was done quite quickly.

4 Once the lower portion of the gondola was drawn, I needed to add the back before adding any more.

5 I quickly indicated several figures seated in the middle, plus a few other shapes that give the impression of the open inside parts of the gondola.

6 Once the craft was completed, I created the rather stylized reflections in the water. This was done fast, with delicate linework and a lighter pencil pressure. I didn't want the blackness of the reflections' outline to compete visually with the rest of the sketch. The reflections should lay on the water.

7 The sketch comes to life when I use rapid shading to create the illusion of light falling over the form.

7

6

Establish Shots to Define Location

My suggestion of leaving people until last will help you focus on the architectural details. To make things easier, begin with what in motion-picture production is called *establishing shots*. These are sketches that capture a structure's place or the viewer's vantage point in the overall landscape, rather than close-up details.

Use the same technique on architectural monuments as on portraits of people. Define the overall shapes quickly, then carefully place the identifying details essential to your subject within those shapes. To me this is a kind of impressionistic style of drawing. Your camera can catch perfect detail, but sketches are for your on-the-spot feelings.

Piazza San Marco, Venice
This sketch took about ten to fifteen minutes.

As is usually the case with fast architectural sketches, they tend not to look like much until you start shading with the blending tool. Then they come to life. I find that the light in the early morning hours and in the late afternoon creates far greater drama in landscapes.

Start Here

Where would you begin a sketch like the one on the previous page? You can't go wrong if you nail down the most distinctive parts or features first.

1 The enormous clock tower dominates the piazza and represents the very center of tourism in Venice. I established its overall outline shapes first.

2 Once I had the placement on the page where this gigantic vertical structure would go, I then carefully sketched some quick details inside the tower and proceeded across the page, outlining and then filling in the unique roof domes that form St. Mark's Cathedral.

PIAZZA

3 Notice how crowds outside the front doors of the cathedral were indicated with tiny vertical black lines along with some tiny white areas to help create the illusion of individual people.

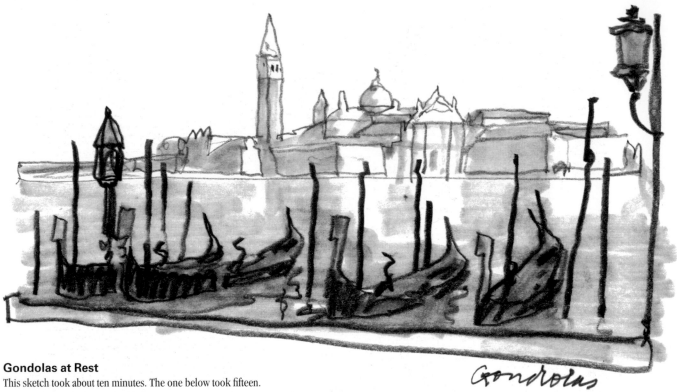

Gondolas at Rest
This sketch took about ten minutes. The one below took fifteen.

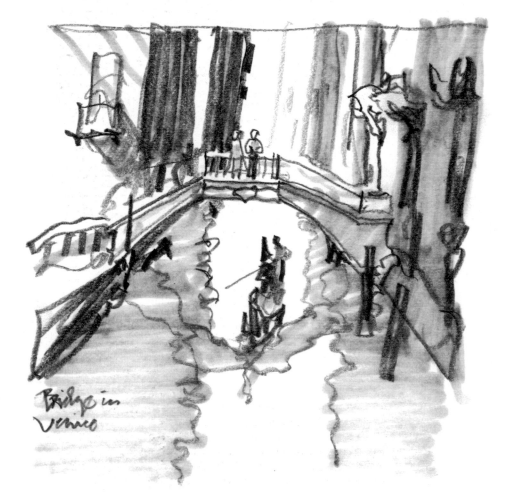

The sketch above is one of my favorites. The gondolas and mooring poles were in deep shadow, with the structures across the way catching late afternoon light. I drew the background structures first, keeping my pencil pressures a bit light.

Then, with a stronger hand I sketched the distinctive gondola shapes in the foreground. The effect immediately creates depth in the sketch, which is greatly enhanced with the shading.

In the sketch at left I began with the center portion of the bridge, then moved on to the rest of the bridge, followed by the figures and the dark building on the right. The gondola is the central focus of the sketch. Just like a portrait—where I'll often build the entire face before placing the eyes—I completed everything before placing the gondola. The shading was done last.

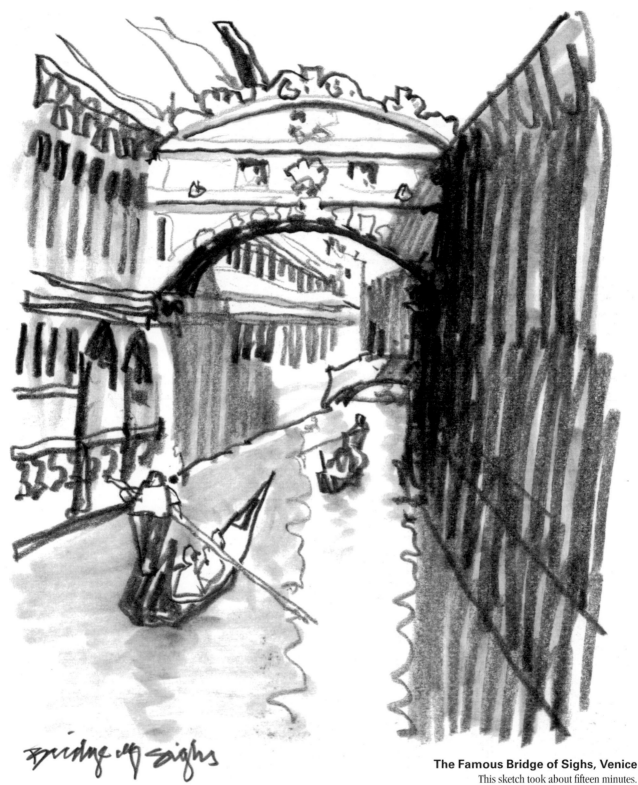

The Famous Bridge of Sighs, Venice
This sketch took about fifteen minutes.

A photograph is a visual snapshot of time, usually mere fractions of seconds, whereas a sketch takes five or ten minutes to create. A sketch is actually a careful compilation of visual elements that pass before your eyes during these few minutes. The gondolas, for instance, were constantly moving up and down this canal as I sketched. I added them last, using pieces of several. I think sketches have far more emotion than photographs, due to the greater length of time spent creating them.

Chapter Three
People

Using All Your Skills

For most artists, sketching people represents one of the most difficult challenges. To create a likeness of someone with just a few pencil lines seems to be bordering on magic. This can create a formidable fear in even experienced artists.

As children we simply picked up a crayon and drew Mommy and Daddy, our pets, our brothers and sisters, our houses and all manner of creatures. We gave little thought to whether these childlike images we drew resembled our subjects. There was just some innocent urge to express ourselves by drawing visual images of things that were important in our world.

Somewhere along the way we lose the confidence in our ability to give visual shape to our personal world. In this section I hope to rekindle your desire to draw people in your life.

In art school, portraiture was my second major. Even so, I still feel real apprehension when faced with new faces and situations. However, I have developed a trust in my skill and know that if I don't react to the fear and just follow my basic techniques, then I will succeed.

In this section, you'll get an intimate glimpse into the very soul of my technique. I'll show you a number of the skills I've gradually developed over the years. You'll also learn how to improve your skills by using a VCR and a camcorder. These can be valuable creative tools in the hands of an artist.

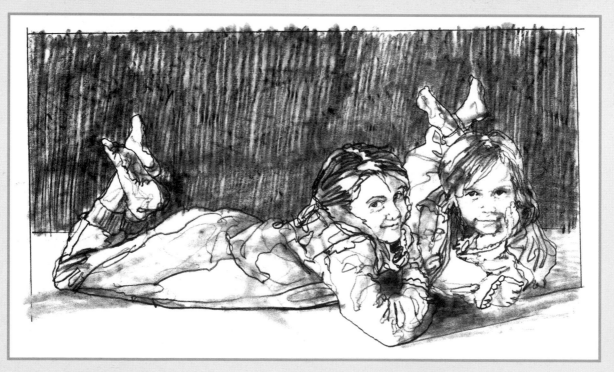

Ashleigh and Shannon DeVito, both age 7.

Sketching people requires a quick eye and a delicate hand.

Suggestions

♦ **Start with freeze-frame sketches.**

♦ **Practice with self-portraits.**

♦ **Work with live subjects.**

♦ **Outline shapes, then shade.**

♦ **Work fast—don't noodle!**

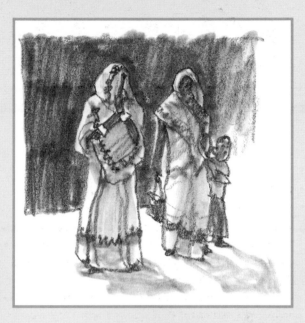

As with everything you've learned thus far, there's a technique or procedure for sketching people and portraits. I suggest you begin with freeze-frame sketching. First try your hand copying my freeze-frame images, then use your own VCR, taping favorite programs and experimenting with a wide selection of images that you choose.

Begin working with live subjects by doing self-portraits in your mirror. Focus your attention on sketching the overall contour shapes of your face and hair first. Use a stop-and-go sketching procedure to carefully develop your linework—little segments at a time. Utilize your shading to add volume and light to your sketch. Shading helps define the mood as well as the structure and likeness.

But most of all, remember to keep working fast—not sloppy fast or in an uncontrolled manner, but as fast as you can with a deliberate, thoughtful hand and eye. If you slow down and start noodling every tiny detail, you'll be drawing, not *sketching*!

Above: Cleveland Indians pitcher Dwight Gooden in windup and delivery.
Top: Hindu ladies at the spice market in Jodhpur, India.

81

What will help me to quickly create a likeness?

Getting Up to Speed

In this section you will work with a number of procedures for sketching people. Landscapes don't move much, and they seldom express opinions about your sketches. But virtually all people have opinions about portraits, especially ones of themselves. This can be the biggest confrontation an artist has to deal with, and because of this fact, many artists avoid people and portraits altogether.

I recommend practicing in nonconfrontational ways in order to avoid criticism. You should feel free to make mistakes so that you'll put in the time necessary to make real progress in your technique.

Techniques to Gain Skill

1 **Sketch from photographs or magazines.**
2 **Begin with rapid linework sketches.**
3 **Sketch from your TV.**
4 **Use your VCR's freeze-frame function to sketch.**
5 **Do self-portraits.**
6 **Sketch friends and family over and over.**
7 **Ask acquaintances to pose for you.**
8 **Sketch strangers wherever you travel.**

Rapid Linework Sketches

In the following procedures I will focus on the correct use of the 9B graphite pencil, since that is the best sketching tool. However, the primary skill in this technique is the ability to quickly create a likeness with only the simplest linework. The shading is secondary since the initial linework defines the essential shapes and details of a person's face or posture, as well as the definition of the shadows themselves.

You can practice drawing fast linework using any of the eight techniques at left. Simply look in a mirror and sketch yourself; sketch out of magazines, books or family photo albums; sketch members of your family or next-door neighbors. Try sketching freeze-frame images using your VCR. In all of these cases you can restrict your sketching style to simple linework for better results. Work on developing a rapid linear drawing technique that outlines shapes and establishes details quickly. If you don't have your sketching pencils with you at the time, use a ballpoint pen.

Morgan Hester, age 2

Linework Plus Shading

Whenever I begin a portrait, I am striving to achieve a likeness of that person. Oddly enough, I find that the likeness more or less emerges on its own if I concentrate on sketching the specific shapes correctly. It's when I forget this and try too hard to capture a good likeness that my sketches fail.

Linework and shading are the two most fundamental aspects of this technique. In the next two pages, study the images and try to create a likeness with only delicate linework, then enhance it with careful shading. Develop your skill with the 9B graphite pencil and the blending tool. These two tools will allow you to create a wide range of aesthetic variation in the shortest amount of time.

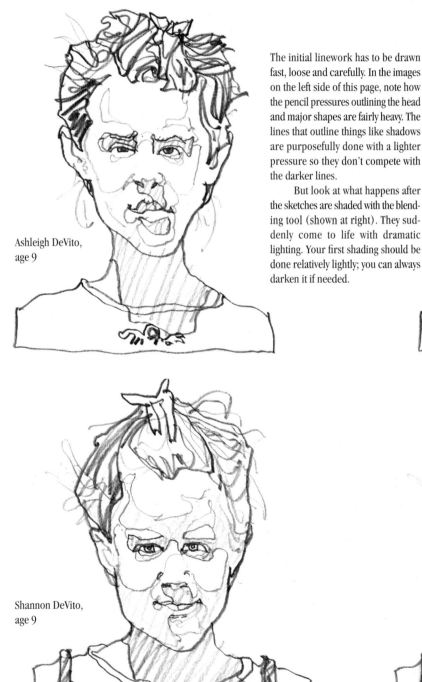

Ashleigh DeVito, age 9

The initial linework has to be drawn fast, loose and carefully. In the images on the left side of this page, note how the pencil pressures outlining the head and major shapes are fairly heavy. The lines that outline things like shadows are purposefully done with a lighter pressure so they don't compete with the darker lines.

But look at what happens after the sketches are shaded with the blending tool (shown at right). They suddenly come to life with dramatic lighting. Your first shading should be done relatively lightly; you can always darken it if needed.

Shannon DeVito, age 9

Sketch Only Shapes That Enhance Likeness

I always begin framing the face by delineating the hair shapes and outlines. You'll notice that the main features always remain a bit darker than shadows and other less necessary shapes. Remember to sketch only those shapes that enhance the likeness of the person you're sketching.

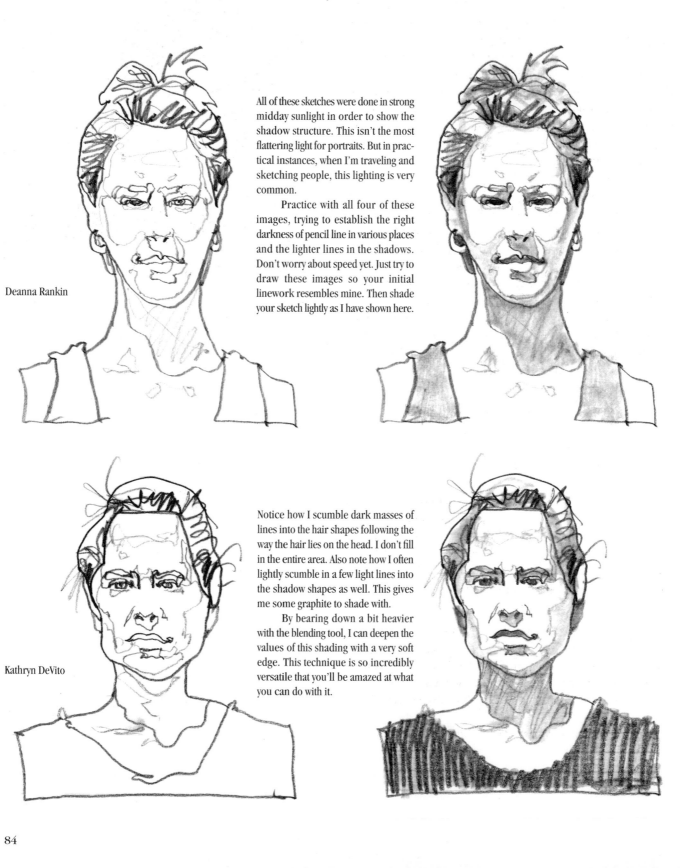

Deanna Rankin

Kathryn DeVito

All of these sketches were done in strong midday sunlight in order to show the shadow structure. This isn't the most flattering light for portraits. But in practical instances, when I'm traveling and sketching people, this lighting is very common.

Practice with all four of these images, trying to establish the right darkness of pencil line in various places and the lighter lines in the shadows. Don't worry about speed yet. Just try to draw these images so your initial linework resembles mine. Then shade your sketch lightly as I have shown here.

Notice how I scumble dark masses of lines into the hair shapes following the way the hair lies on the head. I don't fill in the entire area. Also note how I often lightly scumble in a few light lines into the shadow shapes as well. This gives me some graphite to shade with.

By bearing down a bit heavier with the blending tool, I can deepen the values of this shading with a very soft edge. This technique is so incredibly versatile that you'll be amazed at what you can do with it.

What is freeze-frame sketching?

For sketching subjects, you can begin with magazines or photos, or you can simply turn on your TV and start sketching. But if you want to try something fun, tape something with your VCR, rewind it and play it back freezing it (using the pause option) at various images.

Because people move around so much, and directors love to cut from one scene to another, it helps if you use the freeze-frame feature on the VCR to stop the action long enough to do a sketch. Working with freeze-frame controls you can freeze unique postures of anything. If you have single-frame advance control you can isolate specific postures even better. This works great for sports, dance, adventure, birds and wildlife.

Most VCRs have a protective device that switches this feature off after five minutes. (This protects the recording heads inside the VCR.) It will also keep you working fast, and it provides a great feedback mechanism that teaches you just how fast five minutes goes by.

Analyze a program for unique postures, looks or images to sketch. This will help you develop visual acuity. Using your videotape recorder, you can choose your own visual subjects. Review these programs for suitable images and then figure out how to begin your sketch, and which shapes are the most distinctive. Here are a couple of hints to help you.

1 Begin by focusing on one distinctive feature.

Look for images that aren't too complicated. Focus on only one subject, and omit everything else around it. Try to see the most distinctive visual feature of your chosen subject, and begin your sketch with that feature.

In almost every sketch of the baseball players on the following pages, I started with their caps. There's a really good reason for this. If I can establish exactly where that brim is — and sketch its shape correctly — I can then attach the hat shape, the head beneath the hat, the shoulders and so on. It's simply a way to begin that works about 95 percent of the time.

2 Build your image one piece at a time.

A weakness in your sketching skills can develop if your visual focus and concentration jumps around too much. Study individual shapes exclusively, one after the other. Do not allow your focus to move on until you've sketched that particular shape.

If you can enhance these two skills, you'll be amazed at the results.

Start With Programs You Most Enjoy

Tape your favorite programs. Play them back and freeze selected frames that you think you can sketch. Stay loose; work fast. Then, try another!

These images were sketched from a televised game between the Cleveland Indians and the Boston Red Sox. Most of these sketches took about five minutes because my VCR's freeze-frame feature automatically shuts off after five minutes.

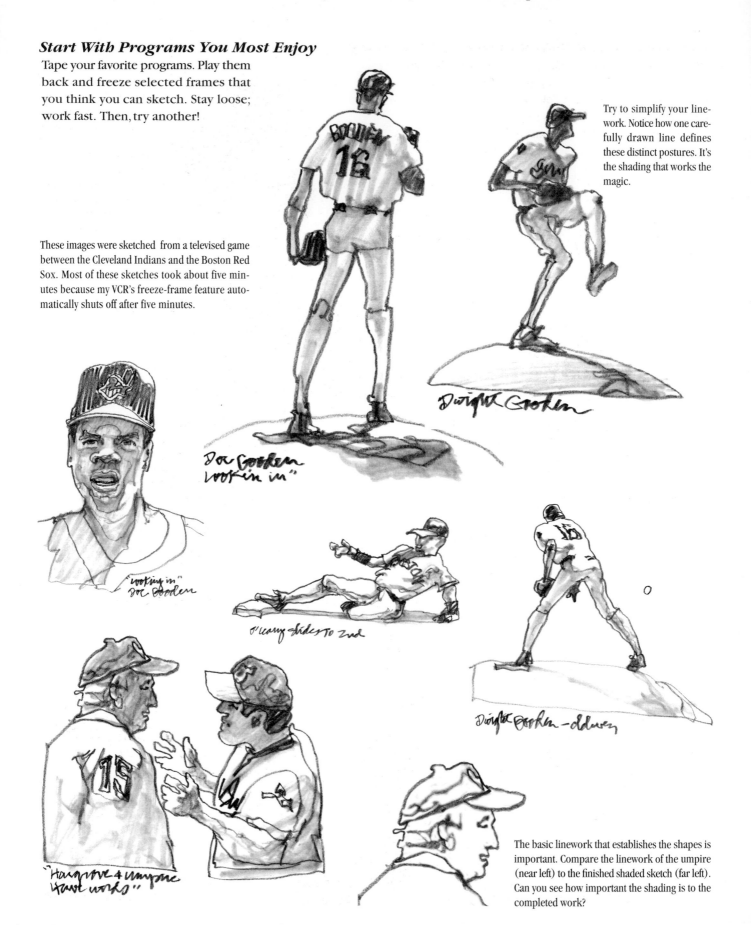

Try to simplify your linework. Notice how one carefully drawn line defines these distinct postures. It's the shading that works the magic.

The basic linework that establishes the shapes is important. Compare the linework of the umpire (near left) to the finished shaded sketch (far left). Can you see how important the shading is to the completed work?

Use Strong, Clean Outlines and Careful Shading

Work with clean outlines carefully drawn to define essential shapes. Connect one segment of the sketch to another until you've got a whole figure. Then merge all the components with careful shading.

Keep your contour and outline shapes strong. Try to draw a shape with one clean, carefully drawn line, rather than five or more light lines. Outline your shadows lightly. This helps define them when you go to blend in your shadow areas.

Notice how I try to keep my shading lines going at a 45 degree angle. This helps create visual balance and aesthetic charm in your sketches.

This portrait of Kenny Lofton checking the sign from the third base coach was the biggest, measuring seven inches (18cm) across. I established all the basic linework before the five-minute automatic shutoff kicked in. Then I did the shading. Total sketching time was about ten minutes.

It's a good idea to identify and title sketches as you do them. It's doubtful that you'll ever again be able to find the exact frame of the video you used as reference.

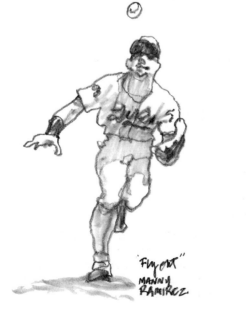

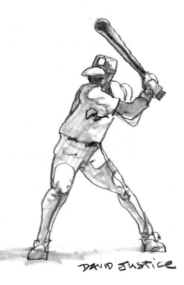

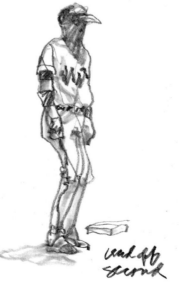

Sketching Sequence

Study the sequence of this sketch, shown at actual sketch-book size, and give it a try. Then go back and try the others. The whole idea here is to have you work from one of my sketches until you get the feel for the sequence I sketch and can see what I'm focusing on as I sketch. You will also recognize what I'm leaving out as I sketch a figure. I focus my attention on the initial linework, capturing only the simplest outline of postures and shapes. Then I gradually add more and more shapes until I've got a finished figure. The shading ties it all together.

1 The pitcher's hat. I began with the round portion of the hat, then added the brim. Next I quickly added his head down to where his neck enters his shirt.

2 The back shoulder, arm and mitt. This is a sketch of a pitcher, so his pitching arm must be correct. By establishing the arch of his shoulder and his arm ending in his mitt, I can now connect the other shapes more easily.

3 The rest of the upper body. It's a lot easier if I can establish the whole upper torso shape so that it looks right.

5 The lifted leg and foot. Once I got the figure drawn from the head to the foot on the back leg, I could then carefully draw the front leg at just the right degree of lift. These legs are drawn with only a single line extending from the hips to the shoes and back.

Once the figure was completed, I added the pitcher's mound and the shadow.

4 The leg he's standing on. When drawing legs on people, birds or animals, I always start from the body and work downward to the feet. Here I drew the lines down to the knee on both sides. Then I continued down into the foot and shoe. The uniform line back up the leg started at the foot and went back up to the hip.

6 The shading. It's the shading that makes a sketch. Ease up on your drawing pressure so that you create light values in the shadows. The harder you press with your blending tool, the darker the shadows will get.

Work With a Camcorder

I frequently use my camcorder as sort of a digital sketch-book. Once I took it to the local Memorial Day parade and recorded snippets of Americana. Then I came home, downloaded the footage onto a VCR cassette and played it back, freezing images of various subjects long enough to do these quick sketches.

Give these sketches of pipers at the parade a try. Be precise and definitive about your linework, then tie it all together with shading. If you've got a camcorder, shoot some of your own footage. It's a great way to improve your eye for subject matter.

Notice how the blending tool provides just the right gray value in the pipers' kilts. How could you create this effect without the blending tool? And even if you could, could you do it in a matter of seconds?

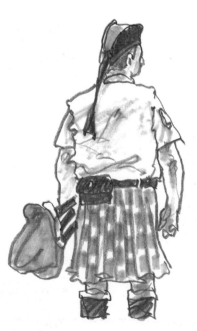

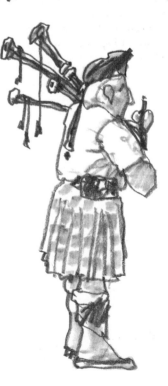

Establish Visual Themes

What I mean by themes is a selective visual subject that you look for when you are out working in a crowd. Be selective; don't just shoot anything. By mentally looking for certain subjects, you learn how to visually focus your attention. This is crucial.

Sometimes I'll limit my sketching, photography or taping to just people in uniforms, couples or people doing odd things. It can be anything. You'll notice that as soon as you develop this habit your productivity will skyrocket. You'll come home with lots of usable visuals.

On this particular day I was looking for and limiting my observation to only those images that *epitomize* America— ubiquitous American-parade sort of stuff. I came home with a ton of material. This is just a little of it.

You can't have a parade without cheerleaders and drum majorettes.

Every Memorial Day Parade across America has high school bands and bass drums.

Here, parents and their children line the street waiting for the sirens, marking the parade's beginning.

There are always a few bikers on motorcycles with polished chrome.

Everywhere there are young mothers carrying their infants.

The streets are lined with thousands of kids waiting for firefighters, police officers and politicians to ride by and toss them candy.

Dads often carry little kids on their shoulders so that they can get a better view in the crowd.

When Sketching Famous People, Less Is More

There are few subjects more challenging than portraits of famous people, since everyone knows what they look like. One of the basic working criteria of most successful portrait artists is to minimize facial details — especially in a woman's face. Few women want to see every pore or wrinkle in a portrait. This goes double for my sketching technique. If you can capture a few of the most basic features of a person's face and hair, you can omit the rest, and everyone will be happy. It's far better to nail down a likeness with the fewest possible lines.

Another trick is to keep the dark values of the eyes, mouth, eyebrows and hair dominant. Lighten up on the pencil pressure when adding other details so they stay lighter and grayer. This helps direct the viewers' eyes to the features you want them to recognize first.

When starting the sketch, ask yourself, What is the person's most distinctive feature that catches my eye? If you can answer this question it will help you sketch that person better and faster.

Katie Couric

Matt Lauer

The *Today Show*'s Katie Couric is a great portrait model to practice with. She has great eyes, a well-proportioned facial structure, nice eyebrows and a stylized shape to her hair.

1 When sketching Katie, start with the wave of hair that falls across her forehead.

2 Next, carefully define her facial shape and jawline from left to right.

3 Then establish her eyebrows.

4 Instead of placing her eyes, do her nose and mouth next.

5 Once all of this is in place you can more easily position her distinctive eyes.

Now try *Today Show* coanchor Matt Lauer.

1 Start with Matt's hair on the left side of the sketch, down to his ear.

2 Next sketch his wave, followed by the right side of his hair, down to the other ear.

3 Once the hair is completed, establish the lower shape of his face from the ear on the left side down to the front and back up to the right side of the sketch to where the hair begins. Do this with one continuous line, pausing momentarily along the way without lifting the pencil.

4 Then place the eyebrows, followed by the nostrils.

5 Place the eyes next, as you study his mouth and lips carefully.

6 Sketch the lips last. Notice the distinct bow-like shape, and the way he pushes his lower lip up into the upper lip. This captures the likeness.

Find Distinctive Features

In doing portraits of famous people I am constantly look-ing for postures, movements, even clothing or hairstyles that stars have developed as part of their personas. With stars like Cher, it's her clothes or her hair; with talk show host Jay Leno, it's his pronounced jawline. These visual elements can become so distinctively associated with a star that they become archetypal, as with Elvis's unique hair and sideburns.

When sketching portraits, this is what you should look for. If you can capture at least something distinc-tive about the person, it can make a portrait.

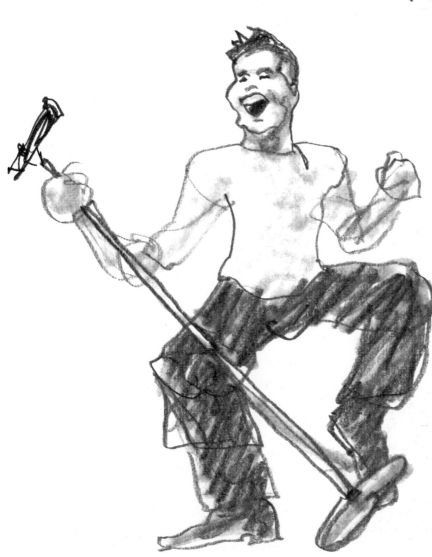

I usually start with the head of a figure first, but with pop singer Ricky Martin, I broke my own rule! His perfor-mances—such as this one on the *Today Show*—are marked by his distinctive dance moves, so I began these sketches by establishing these unique postures first.

How do I define facial and body structure?

My initial outline drawings of individual shapes, such as the hats on professional golfers Tiger Woods and the late Payne Stewart, are strong and definitive. Try to define a shape with one well-conceived line rather than a mishmash of lighter lines struggling to find the correct shape by trial and error.

Lighten up on your pencil pressures when defining the shadow areas of a face. I actually outline these shadow shapes as well, filling them in with a light scumble of lines that are then blended and shaded into a nice midvalue gray. Notice the same value principles apply to people as we use in landscapes — a darkest dark, the white of the paper and a midvalue gray.

These sketches show examples of variations in linework pressures and outlining shadows to define facial structure.

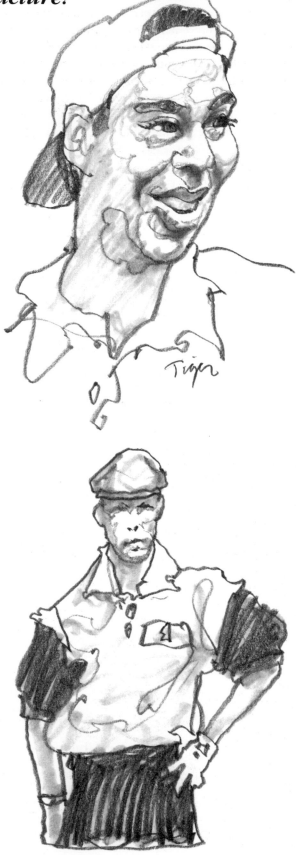

These sketches of Tiger Woods (right) and Payne Stewart (below and bottom right) were taken from a videotape of the 1999 U.S. Open golf tournament.

94

Vary Line Pressures

Once you work with this technique a bit you'll soon begin to develop the advanced ability to vary the physical pressures you use when you sketch. The sketch below of Payne Stewart as he exploded with exuberance the moment after he sank the winning putt at the 1999 U.S. Open shows these variations clearly.

The outline of the major shapes — such as those that define his cap, his carefully drawn profile and his eyes — were all drawn with a fairly strong pressure. But notice how I lighten up when I'm outlining the shadow structure in his face. These shadow outlines are merely guides that help define the way the light falls over the face and form. I then carefully fill them in using only the blending tool to create subtle variations in this midvalue gray.

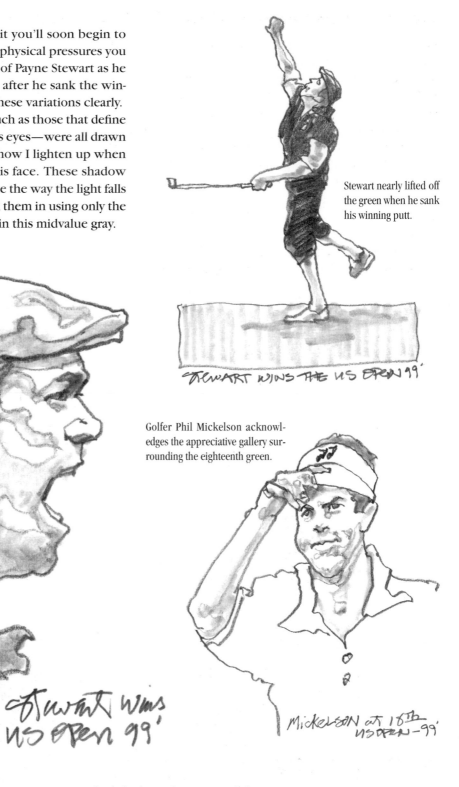

Stewart nearly lifted off the green when he sank his winning putt.

Golfer Phil Mickelson acknowledges the appreciative gallery surrounding the eighteenth green.

Stewart was so elated when he won the tournament he literally screamed at his caddy, his family and the whole world. I love sketching moments like this. Notice the delicate quality of light I captured in the shadows.

Look for Unique Expressions

When sketching people on television shows, look for those unique expressions that are indicative of certain characters. The TV show *Ally McBeal* is filled with characters whose expressive facial looks literally define their characters on the show. This makes sketching them fun.

As usual, with these sketches from the show, I started with the hair shapes. As I mentioned with the sketch of Katie Couric, *less is more*. Ally's unique look is epitomized by her propensity for puckering her lips into a faux kisslike position as she opens her eyes as wide as possible, punctuating a dramatic moment.

Ling, on the other hand, has a stoic, masklike appearance, with well-defined lips and dramatic eyebrows, framed with coal-black hair. The very eccentric "Biscuit" has an unruly hairline, a pronounced frown and squint, and an expressive mouth.

If you can practice with these sorts of faces, it will help you sketch virtually anyone. You will begin to see their distinctive features faster.

Ally McBeal, on a never-ending neurotic search for love.

"Biscuit," an eccentric partner in the law firm.

The dramatic, beautiful and inscrutable Ling.

How should I get started with live subjects?

The rest of this chapter deals with live subjects rather than freeze-frame or photographic subjects. Now everything you have practiced will come into play to help you sketch anyone, anywhere, in only a few minutes.

If you can create a sketch of yourself in just a few minutes, then maybe you can sketch someone else as well. This is where you'll begin to see if you've improved your skills.

Don't rush this exercise. Practice making exaggerated faces and expressions. Make a habit of doing five self-portraits a day for a week or so, just to improve your self-confidence. As soon as you feel ready, work with a family member or friend. Remember this is fast sketching, so you can do a number of sketches in a short period of time. Don't get hung up noodling a likeness. Work fast and loose.

Sketching Sequence

To create a rapid sketch of a person requires the very same skills you use to sketch a portrait of an animal. Begin with the most distinctive features and shapes first.

1 When sketching live subjects, try to frame the basic shape of the face first, beginning with the overall contour line of the hair.

2 Then connect the face and jawline with a clean, carefully drawn outline, trying to capture the essence of the shape.

3 Once the basic structural shapes of the hair, face and jawline are established, it is easier to place the eyes, nose and mouth correctly.

4 Vary your pencil pressures when drawing and defining the outlines of shadows. These are merely meant as guides and should not compete with the main features. Lightly scumble in some lines into these shadow areas, then shade them with your blending tool. This establishes the light source, volume and structure, and it gives life to your sketch.

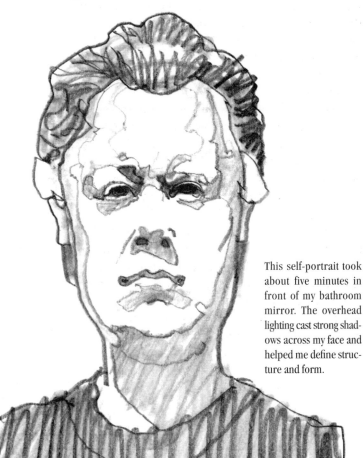

This self-portrait took about five minutes in front of my bathroom mirror. The overhead lighting cast strong shadows across my face and helped me define structure and form.

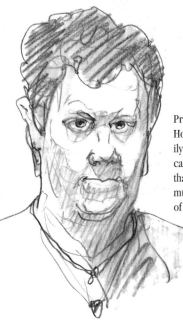

Practice by trying to capture expressions of all kinds. However, when it comes time to sketch a friend or family member, stick to less expressive facial poses. People can hold a more relaxed expression easier and longer than one that shows a big smile or grin. Plus it makes it much easier to capture a likeness if you can avoid lots of teeth.

Sketching in Crowds

I had been out sketching and photographing in the streets of Delhi since early morning. My wife, Deanna, and I were walking up Janpath Lane toward our hotel when Deanna decided to negotiate with a young girl for an embroidered tablecloth. The sales girl, Shardha, was lovely with her large, dark-rimmed eyes, nose ring and a beautiful Kashmiri shawl draped over her shoulders.

After Deanna established the final price, I asked the young woman if she'd pose for me for a few minutes. Shardha sat for a portrait while her family and friends gathered around to joke and observe. It was very entertaining.

✍ **Begin With This**

Many portrait artists recommend you start with the eyes, but I have found that by first establishing the overall shape of the head and hair, it frames the face and allows me to place the features more easily.

The subject of this portrait had such a distinctive mouth and eyes that I had to carefully establish her head and pulled-back hair, as seen above. This was how I began this sketch.

Then, I quickly filled in her dark hair in order to frame her face. Next I did her eyes, nose and mouth. It was only after this that I concentrated on her clothing details. Total sketching time was six to seven minutes.

While I was sketching Shardha, Vijay stood behind me making jokes with her and the other ladies. I was so focused on doing her sketch that I hardly noticed him until I was finished. Afterward, I took one look at him with his shiny black leather jacket, moussed hair, mustache and dramatic eyebrows and asked him to pose, too.

This is an excellent example of focusing on and sketching the most distinctive shapes first. I started by studying the overall shape of his long, narrow face, with his dramatic hair rising up and framing the face beautifully. You can see below how by capturing this initial shape quickly the rest is much easier.

✍ *Begin With This*

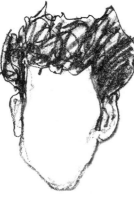

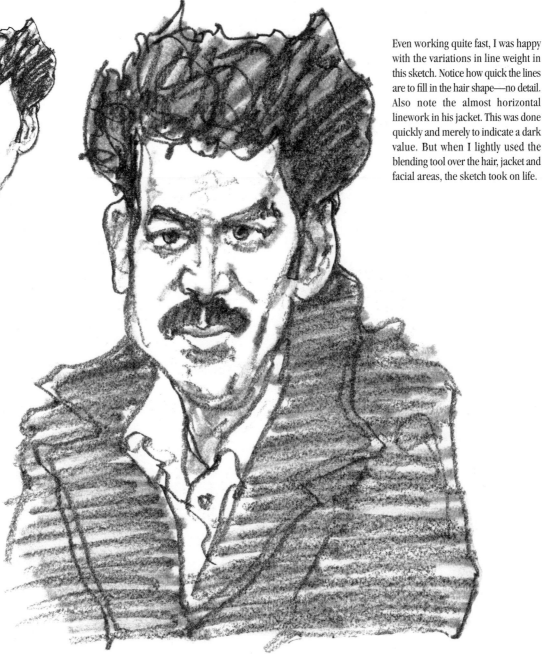

Even working quite fast, I was happy with the variations in line weight in this sketch. Notice how quick the lines are to fill in the hair shape—no detail. Also note the almost horizontal linework in his jacket. This was done quickly and merely to indicate a dark value. But when I lightly used the blending tool over the hair, jacket and facial areas, the sketch took on life.

Sketch Available Subjects Again and Again

I find it very helpful to sketch the same subject many times—in different moods, times of day and so on. In this way you not only get familiar with a subject's features, you also loosen up and draw the person a bit differently each time. Shannon and Ashleigh, the daughters of one of my best friends, were visiting one summer day while I happened to be sketching flowers in my garden. I took a few minutes and had them sit on the edge of the pond for a sketch or two.

It was late afternoon and they both needed a snack, and were rather bored with my request to pose. This even came through in their sketches! I love this sketch of Shannon, but she calls it the "chubby cheek" drawing.

This sketch actually didn't look like much until I switched to the blending tool and developed the light shading and light source. I cannot emphasize enough how important the shading of midvalue gray is to the overall success of a sketch.

✍ **Begin With This**

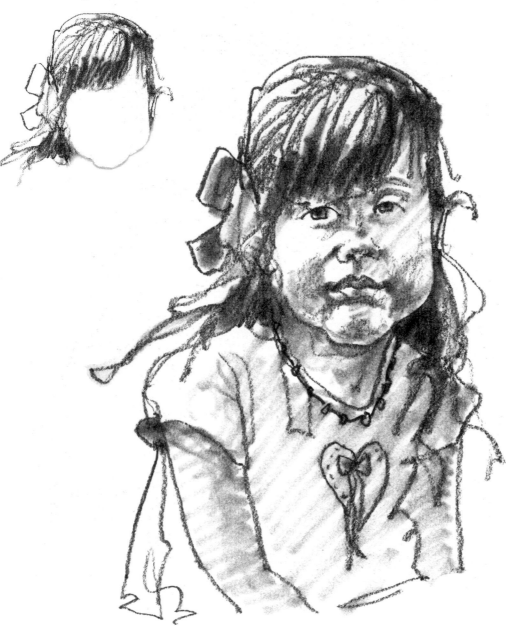

Sketching Sequence

Study the sequence for Shannon's sketch, then give it a try yourself.

1 I began by establishing the overall shape of Shannon's hair and jawline. The wind was blowing her long hair around, so I tried to indicate this.

2 By delineating the overall head shape, with the distinctive bangs and the bow poking out from behind, I could then concentrate on capturing the mood and placement of her features.

3 Once I got the placement of the eyes, nose and mouth, I switched to the blending tool to establish the shadows and light source.

4 Even though this sketch only took about five minutes, Shannon began to fidget and move around. But it didn't matter; I had already captured her look. It was easy to add her arms and torso, with the heart on the T-shirt and her favorite necklace around her neck.

Fast Sketching Techniques ✍ *People*

Use Defined Shadows to Establish Facial Structure

The beauty of this technique is how it allows you to rapidly create specific moods with strong or subtle lighting. Sarah Manning, my neighbor and an artist herself, was playing with Ashleigh and Shannon on this same summer afternoon. The light was very bright, and I wanted her to face a bit toward the sun to allow strong shadows to fall across her face.

The brightness made her squint some, which comes through in the sketch. But look how easy it is to create not only the strong, direct shadows but also the subtle, reflected light illuminating the shadowed side of her face.

The outline shape of the hair is first. Then I try to establish the basic shape of the face by drawing the inner hairline, ear and jawline. These are the most difficult shapes to capture, as they form the basic overall shape of the head. If these are wrong at this point, start over.

I position the eyebrows next. This helps me place the nostrils and then the mouth in the right positions. These elements then guide where the eyes go.

Developing a Portrait

When developing an image for a portrait commission, I use a whole host of coordinated imaging skills that begin with sketching out my initial ideas rapidly.

Sketching is where you do your most creative visualization. In this case, I was working on developing a watercolor portrait of Ashleigh and Shannon for their grandmother.

I was preparing to photograph them in these beautiful, gold reflective party dresses. Even in a photo shoot, I think with my pencil first. Only after I've studied my subject and formed some ideas that I've sketched out quickly will I begin to take the shots that help me develop the ideas I've sketched. This is a crucial procedure.

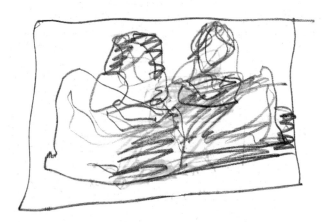

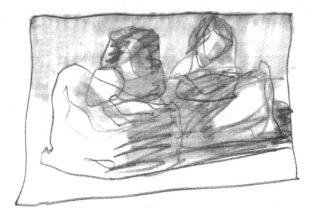

1 You can see how fast and loose this initial idea development is—only some quick postural studies to try out a composition.

2 Then with my blending tool I quickly established the strong light source that created the large dramatic shadow design I was looking for.

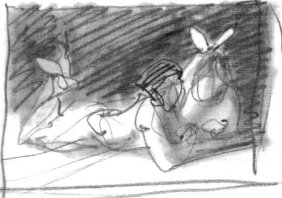

3 But then I had another idea in which the girls were in their pajamas. So I had them change into their pj's and assume this position on the floor. In many ways I liked this composition better, as it allowed me to design their feet into the composition and bring their faces closer together. These first three sketches were done on location in the photographic shoot at their grandmother's house.

4 This one was created back in my studio, working from the slide images I had taken. As you can see, it is a much more detailed and carefully designed study. This is not a sketch—it is a more refined drawing that incorporates all of my thinking and that allowed me to test out the idea visually to see if I liked it.

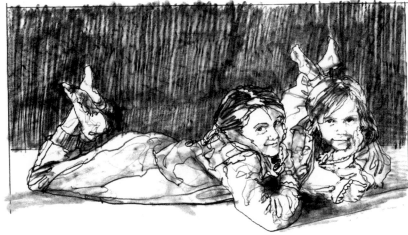

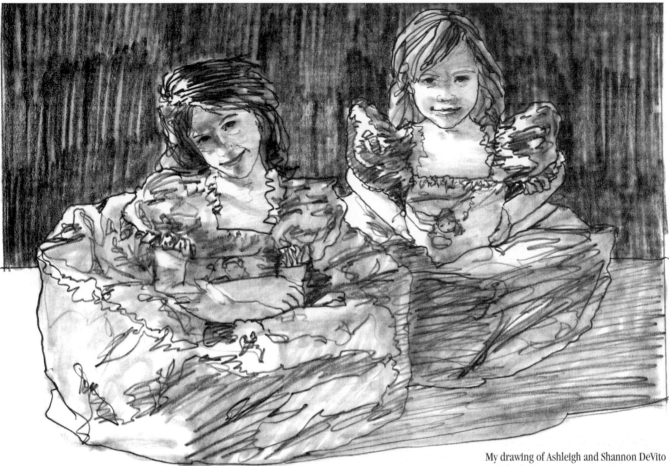

My drawing of Ashleigh and Shannon DeVito
in their party dresses.

Advanced Studio Work

A finished watercolor commission can take me several weeks of preparatory work to develop a design I'm happy with, and then the actual painting can take another week or more to paint. So I can't afford to make mistakes in the finished painting.

This is when both my sketching and drawing skills come in handy. The pencil study above—based on the first two sketches of the girls on the previous page—took a good hour to develop. From this study I can clearly ascertain whether this will make a good painting.

If I still have questions at this point, I'll often go even

further by doing a small watercolor study that allows me to check out various lighting effects and color choices, especially in the reflected light areas.

I'll continue developing sketches, drawings and studies until I'm certain of my composition and design. This may seem elaborate, but this is common practice among professional artists who earn a living from painting.

Many of my watercolors are more spontaneous than this, but when a subject has to be dead-on perfect, all of this preparatory sketching and drawing makes the finished painting great.

Making Friends Sketching Strangers

On our most recent trip to India, Deanna and I were in the airport at Jodhpur, Rajasthan, waiting for our flight. We had about an hour before the plane was due, and the airport, which is small, was very quiet. I decided to do a little sketching.

I walked over to one of the guards and asked in my limited Hindi if I could do a sketch of him. He looked me up and down suspiciously, as did the other officers. Then he gave me a big smile and stood at attention.

I said, "No, no . . . *serious*," meaning that I didn't want a big smile; I wanted his more stern look. The other guards all gathered around me studying my every pencil stroke and instantly comparing it to his face, all the while trying to make him laugh.

He finally started to laugh, and I immediately stopped sketching and said to him in a formal voice, "No, no . . . serious, please!" At this he instantly vanquished the smile and returned to a straight face while his buddies howled with laughter, crying out, "No, no, Aadu Ram, the sahb wants serious!"

This was great fun, and I did several of the guards one after the other. Each time it was, "No, no, the sahb wants serious!"

The word came that our plane to Delhi would land in fifteen minutes, so the manager, Mr. Sheikh, quickly positioned himself squarely in front of me and stated emphatically, "Mr. Rankin, I am in queue now!" He was concerned that I was finished sketching, so he basically demanded to be next.

By the time Deanna found me, I had all the military guards and administrative airport people crowded around me, joking and carrying on. It was wonderful. And when the plane came, they let us on first. Deanna took their names and addresses and sent all of them reproductions of their sketches after we got back home.

With all three of the guards and Mr. Sheikh, I started with the tops of their heads. By first establishing the hat attached to the outline shape of the face, ears and jawline, I've got a firm beginning. If this shape isn't correct the sketch will fail long before getting to the eyes. This sketch of Aadu Ram, as well as the others, took five minutes.

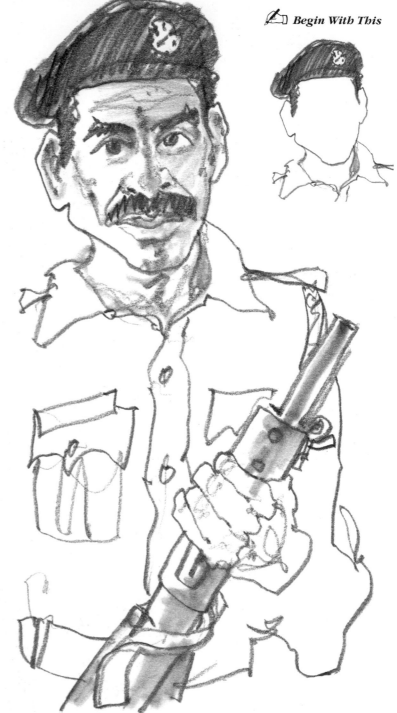

✍ **Begin With This**

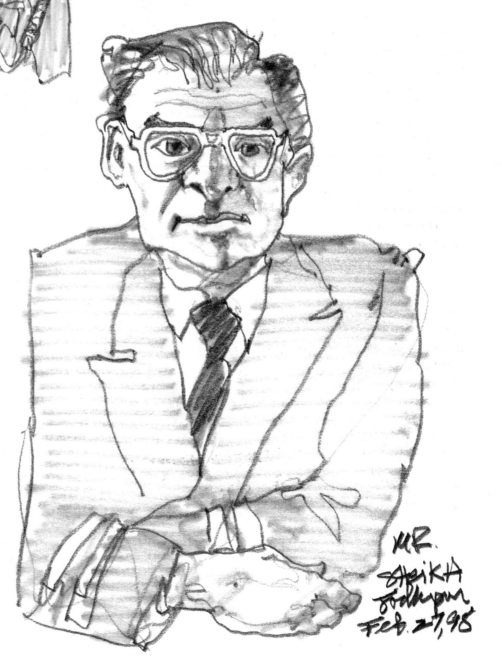

I actually did Ridmal Ram's sketch a bit smaller and then used the blending tool to try a gray midvalue shade to indicate the color of his khaki uniform and beret. I felt it took something away from the linework.

✍ *Begin With This*

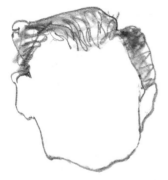

Mr. Sheikh was last. The shape of his face, with the wave of his hair and square jaw, created a distinctive frame that helped me position his glasses, nose, mouth and eyes.

What I liked most about this sketch was the strong shadow and reflected light that the blending tool allowed me to create in seconds, bearing down a bit firmer down the center of his face where the full intensity of the light merges over into shadow. The blending tool allows for just the right softness in the shading and creates depth in the structure of his face.

105

As you sketch more and more people, you'll find that some subjects almost sketch themselves. Nemi Chand was one of those subjects. His large eyebrows, deep-set eyes, square jawline, mustache and ears—all packaged into a crisp, clean uniform—made a great subject with such distinctive character that his portrait was a joy to sketch.

Try to do a quick sketch of Nemi Chand following my brief guidelines below. Hopefully by the time you finish this book, you will have enough courage and confidence in your own sketching skills to go out and find your own subjects to practice on.

1 Start with a quick, simple outline of his hat, ears and distinctive jawline. You can easily see at this stage that the shape itself makes it easier to place the eyes and features in the correct positions.

2 Once you've established the shape of the face and hat, carefully add his facial features beginning with his distinctive eyebrows, then eyelids and finally the eyes. Notice how they are flat on the bottom, as they are partially hidden by his lower eyelids.

3 Begin his nose with just the nostrils, then his mustache followed by his upper lip.

4 To define and indicate structure, lightly outline the shadow areas. Then add some light horizontal lines scumbled into these areas. These are only meant to be used as value when blending them.

5 Use the blending tool for subtle shading by smudging the graphite linework. Deepen the value along the bridge of his nose, chin and eyes by pressing a bit harder with the blending tool, darkening the shading.

6 Finally, quickly sketch his uniform. In my sketch, I could have shaded in his uniform as I did on the sketch of Ridmal Ram on the previous page, but that would have taken away from the impact of his face.

Sketching People in Action

You have to simplify and sketch small when your subject is moving. My rule of thumb: The faster an object moves, the smaller the sketch should be. The reason for this is simple: Smaller sketches take less time. Here are a few from my India sketchbooks that show what I try to capture when I'm working quickly in crowds of people—only the very simplest of shapes and shading.

The ladies in saris to the right were in the spice market in Jodhpur. The reason this sketch is a bit more finished is because I was able to study them for several minutes as they worked their way slowly down the lane from one spice shop to another.

Whether you are wandering about your local mall or a spice market in the desert regions of India, the same rules apply. Think about why you are sketching. Remember that you aren't trying to create finished art. What you are doing is exercising your artist senses. You are sketching in order to establish a visual link with the world you live in. You can back up your sketches with slides, but it's your sketches that give you your strongest connection with a subject.

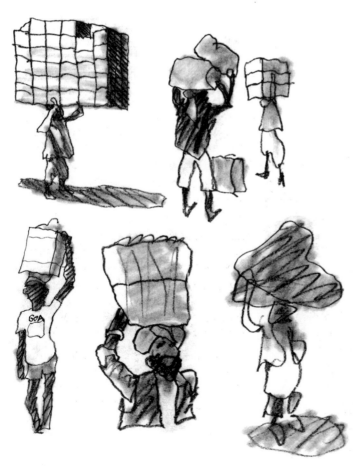

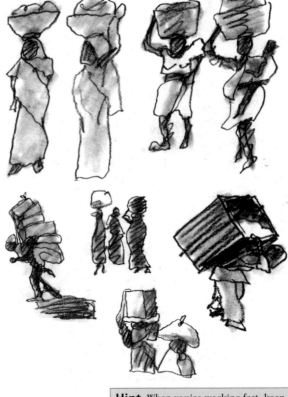

Hint When you're working fast, keep your blending tool in your hand. I switch back and forth rapidly from sketching to shading.

107

Chapter Four
Animals

Critters, Critters, Critters

Like many other children, when I was a kid I loved drawing birds and animals, as well as fanciful creatures I made up.

When I was in art school the term "wildlife artist" didn't even exist. In fact, if I had told my instructors that I wanted to draw and paint animals, they would have thought I was nuts.

But today, wildlife art signifies a two to three billion-dollar industry that incorporates artists, galleries, framers, book and magazine publishers and an entire worldwide network of workshops, museum exhibitions and international art auctions.

In fact, I am on the board of the world's most celebrated group of painters and sculptors who specialize in creating works of art utilizing birds and animals of all kinds. It's called the Society of Animal Artists, and it boasts a stellar membership of more than three hundred of the world's top artists.

So popular is this genre that there are now substructures within the field specializing in very specific types of artwork and artists. Just as in the medical field there are numerous highly specialized fields of professionals, there are now artists who specialize in nothing but birds. There are artists who paint and sculpt only horses, or fish. There are specialty artists who paint only ducks, geese and game birds and who target 95 percent of their artistic efforts toward competing in big hunting and fishing stamp exhibitions.

I know artists who only paint African wildlife, and some who only do North American. It's a whole new world out there. The opportunities for young artists to envision a lifetime career in this field have been solidified by several generations of fine artists who have paved the way for the rest of us.

The most important skill artists need for this field is the ability to sketch and draw animals accurately, beautifully and quickly. In this chapter, you'll learn my most prized techniques for sketching all kinds of birds and animals.

Suggestions

- ♦ **Sketch in zoos and in the wild.**
- ♦ **Begin with unique postures.**
- ♦ **Leave the spots for last.**
- ♦ **Build sketches like puzzles— place distinct shapes, then tie them together with shading.**
- ♦ **Back up sketches with slides.**

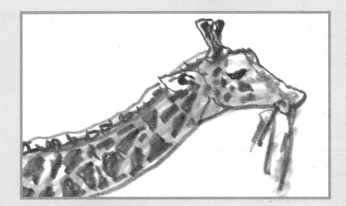

If you want to sketch birds and animals, you can travel to the far corners of the earth and study them in the wild—or visit your local zoo.

With birds and animals, the unique postures they exhibit are often intrinsic to the visual identification of a particular species. You want to develop an eye for this kind of uniqueness, and then be able to sketch it quickly.

No matter what the species, concentrate on getting the basic shapes and postures correct first. Then, and only then, should you add the identifying spots, stripes or markings.

Build your sketches like a puzzle—piece by piece. This helps you draw faster and much, much easier.

And lastly, get yourself a good camera. No matter how well you can sketch, you'll still need to back up your sketches with good photographs or slides.

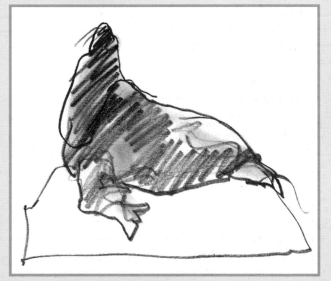

Left-hand page: Langur monkey in Jaipur, India.
Top left: Hornbill in the Pittsburgh Aviary.
Top: Siberian tiger in the Cleveland Metroparks Zoo.
Middle: Giraffe in the Cleveland Metroparks Zoo.
Bottom: Large bull seal in the Cleveland Metroparks Zoo.

What is the secret to improving my animal sketches?

One of my best known watercolors of animals is this painting of an African warthog I created for the Cleveland Zoo several years ago. To do this

painting I had to create a lot of preliminary sketches trying to capture just the right look and mood. I realized back then how important it was to develop sketches in pieces, just like in a puzzle.

The ability to create a sketch of a landscape, a person or an animal requires you to observe the subject, see basic shapes within that subject, and

The Warthog

then quickly and effectively sketch those shapes. This is how I *assemble* a sketch. It's just like putting together a jigsaw puzzle one piece at a time.

In sketching, birds and animals just don't get it. They don't much care that we'd like them to stop for a couple of minutes. So the technique for sketching critters has to be thought through pretty well or you'll get discouraged.

I suggest that you get up to speed first by working with

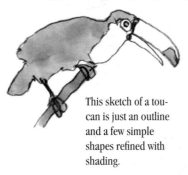

This sketch of a toucan is just an outline and a few simple shapes refined with shading.

the sketches shown in this section, as well as photographs and the freeze-frame sketching technique outlined on pages 85–89.

Inexperienced artists often make the mistake of trying to envision a completed sketch. Or, they don't envision anything and just flail along hoping the sketch will somehow develop if they make enough marks on the paper. Both of these are wrong. The way to achieve better results is to make an effort to sketch *parts* rather than the whole object.

The pyramids of Egypt were constructed with singular blocks of stone. A sketch of a bird, a tiger or a baseball player works in the same way—each is actually made up of smaller parts.

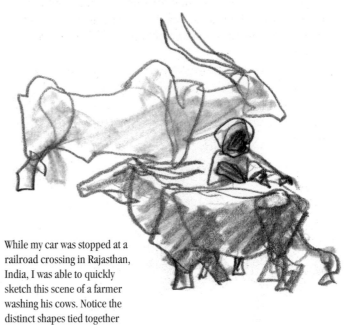

While my car was stopped at a railroad crossing in Rajasthan, India, I was able to quickly sketch this scene of a farmer washing his cows. Notice the distinct shapes tied together with shading.

If you can develop the ability to see the pieces or shapes that form a bird or animal, it will improve your sketches of them, as well as your sketches of people and landscapes.

An Example

The sketch above of cows being washed in a river illustrates the most essential point in this technique. Instead of trying to sketch the whole cow or scene, I look for the simple shapes that make up the cow. Look at this sketch carefully. If you take away the shading and scumbled lines, can you see how my cows are constructed simply with selected shapes?

I sketched the darker cow at the bottom first, beginning with its front shoulder and leg. Every other shape was then added to this first shape, almost like a jigsaw puzzle, piece by piece until I had a completed image that resembled the cow. Then I shaded the shadow structures—and that's all. I sketched the second cow in a similar manner.

This is the *secret*! And this entire chapter is designed around this incredibly easy way to sketch.

Start With Flamingos

As you begin to look around for suitable animal subjects to sketch, try flamingos! This is what I start with in my children's Zoo Artist classes, because these birds are so simple.

If you study flamingos for a minute you'll see that they consist of just a couple of shapes and a leg or two. They are usually either sleeping on one leg or nestled down onto the ground in a neat package. Practice sketching them in the examples below.

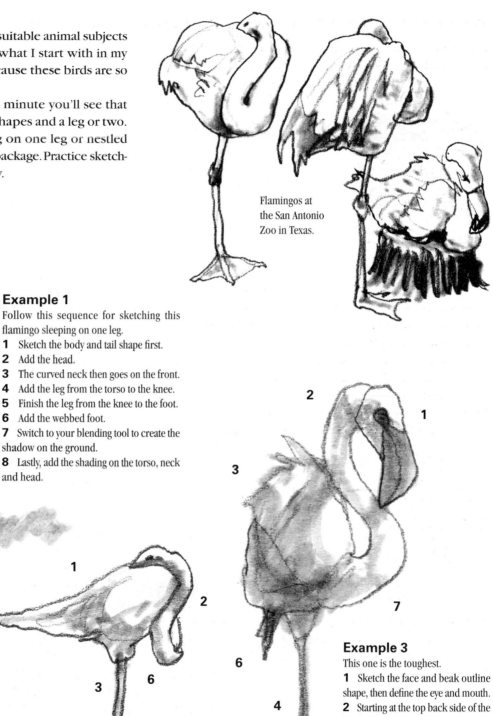

Flamingos at the San Antonio Zoo in Texas.

Example 1
Follow this sequence for sketching this flamingo sleeping on one leg.
1 Sketch the body and tail shape first.
2 Add the head.
3 The curved neck then goes on the front.
4 Add the leg from the torso to the knee.
5 Finish the leg from the knee to the foot.
6 Add the webbed foot.
7 Switch to your blending tool to create the shadow on the ground.
8 Lastly, add the shading on the torso, neck and head.

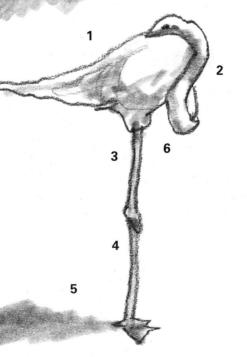

Example 2
This one is a little harder due to the neck shape.
1 Start with the torso and tail shape.
2 Then add the S-shaped neck and head wrapped up and over the front.
3 Add the leg only from the torso to the knee.
4 Then add the portion from the knee down to the foot.
5 Now switch to your blending tool and create the shadow.
6 Finally, shade in the leg, torso, neck and head.

Example 3
This one is the toughest.
1 Sketch the face and beak outline shape, then define the eye and mouth.
2 Starting at the top back side of the head, draw the neck curve down to where it connects to the torso. Then add the other side of the neck.
3 Sketch the torso and tail.
4 & 5 Add the legs in steps as before.
6 Add the foot.
7 Then shade to indicate a strong light source and shadows.

Go to Your Own Zoo and Try

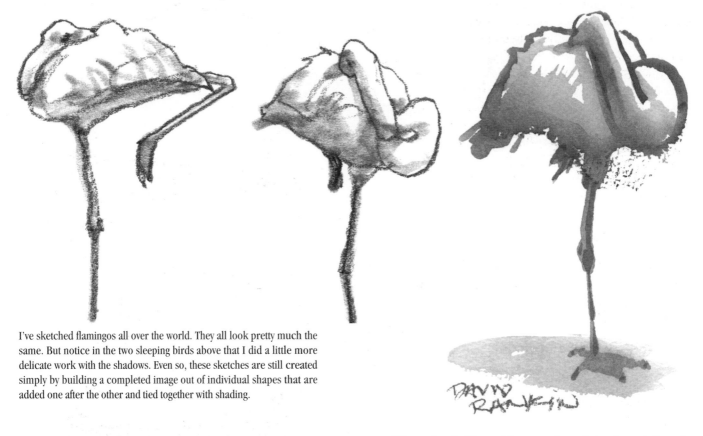

I've sketched flamingos all over the world. They all look pretty much the same. But notice in the two sleeping birds above that I did a little more delicate work with the shadows. Even so, these sketches are still created simply by building a completed image out of individual shapes that are added one after the other and tied together with shading.

This one above is different. It is a watercolor study done in my studio working from the sketch on the near left. You can see how similar my watercolor sketching style is to my graphite studies.

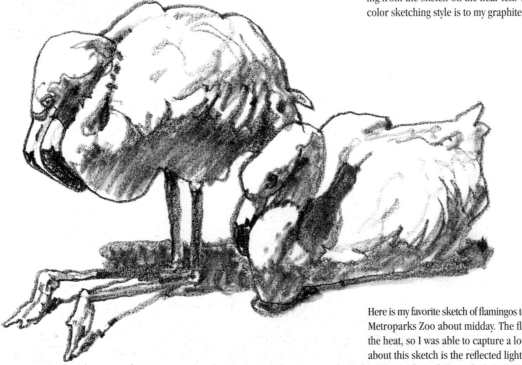

Here is my favorite sketch of flamingos to date. This was done at the Cleveland Metroparks Zoo about midday. The flamingos were totally zonked out in the heat, so I was able to capture a lot of detail quickly. What I love most about this sketch is the reflected light in the shadows. Notice how it all is built out of carefully crafted shapes defined by strong singular contour lines of varying pressures.

A Tortoise in Four Simple Shapes

The Cleveland Metroparks Zoo has several large Galapagos tortoises. On this day they were up roaming about their enclosure so I took the opportunity to do a few quick sketches.

After a while you simply get used to looking at animals as shapes, rather than what species they are. This helps immensely as you try to sketch something, for you are actually seeing your subject rather than interpreting what you think you should see or draw.

Here is a sketch of a tortoise in four stages.

A1 Since I usually start with the shapes that most distinguish a subject, I began with the shape of the large shell on the tortoise's back. Note that I left out the internal shapes on the shell at first.

A2–4 Then I added its legs, and finally its long neck and head.

B In this stage I defined the shell shapes and the shadow area under the tortoise.

C In the final stage I used my blending tool to create some light-value shading. Total sketching time was three to four minutes.

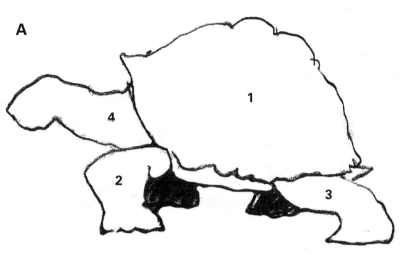

A

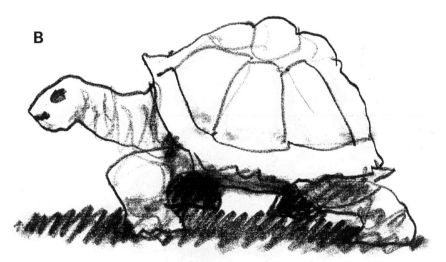

B

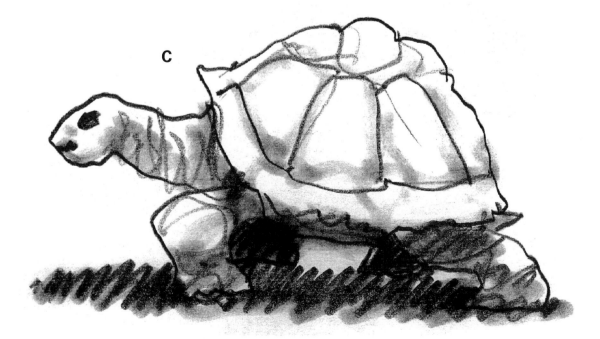

C

Butterfly on Flowers

Study this sketch for a few moments before you start to draw. Also review the sketching sequence to familiarize yourself with the step-by-step construction of the sketch.

The goal is twofold: (1) You are trying to create a sketch that looks something like mine, and (2) you are trying to sketch it fairly quickly. You'll see that there really isn't a whole lot of detail in this sketch. Keep it simple. Refer to the sketching sequence if you get lost. Once you can do one that looks similar, try it again without consulting the sketching sequence.

1 Quickly sketch the butterfly leaving room for the flower below. Then come down below the butterfly's body and sketch some flowers and stems.

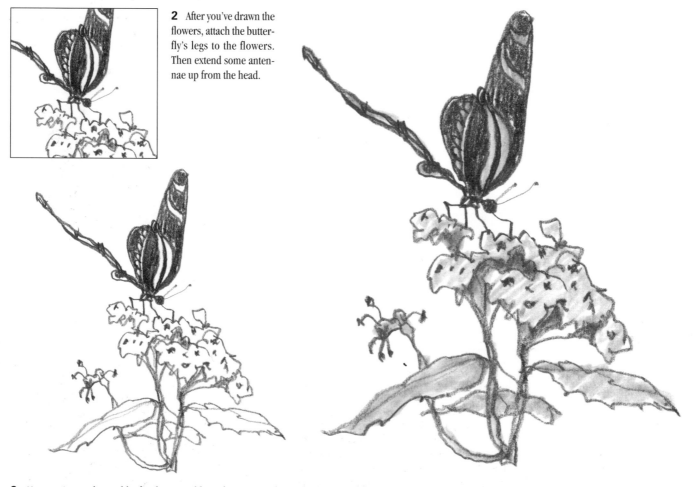

2 After you've drawn the flowers, attach the butterfly's legs to the flowers. Then extend some antennae up from the head.

3 Now you're ready to add a few leaves. Add another stem with a spent blossom up behind the leaf on the left to add dimension to the sketch.

4 The last step is to switch to your blending tool and lightly shade over the white shapes in the butterfly's wings, and then shade the petals, stems and leaves.

Combining Basic Shapes

Sketching and shading structure is much easier if the subject has some distinctive shapes.

Here are some sketches from my children's Zoo Artists class at the Cleveland Metroparks Zoo. Their sketches show how well children can do when they are shown correct sketching sequence.

First I have the students stand close around me and watch the order in which I draw the shapes. They watch me focus on a specific shape and then draw that shape. Then I have them follow my procedure step by step.

In this way they are able to build a rather accomplished-looking sketch, which really encourages them.

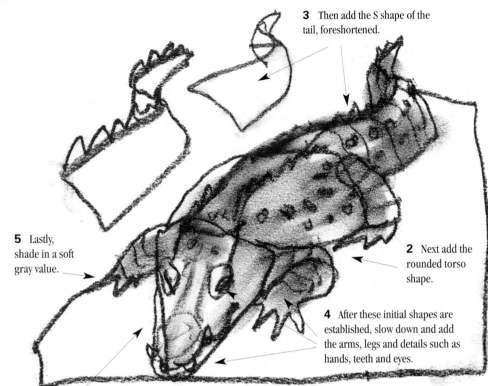

3 Then add the S shape of the tail, foreshortened.

5 Lastly, shade in a soft gray value.

2 Next add the rounded torso shape.

4 After these initial shapes are established, slow down and add the arms, legs and details such as hands, teeth and eyes.

1 Start with the head and snout shape.

Note the confidence of these children's sketches. No timid linework here!

Rachel
age: 11

Katie
age 10

In all three of these kids' sketches, they were able to follow the sequence and shape structure quite well for their ages. What I liked most was how strong their linework was. It makes it much easier to see your mistakes if you create bolder lines. At least then you can see what you need to fix. If your linework is light and timid, it makes it more difficult to correct technique. Be bold and fearless!

Lorna 9

Build Pelicans Shape by Shape

Here are some sketches of pelicans done in Florida on Captiva Island. These are excellent examples of how to build an image shape by shape.

As you sketch a subject, any subject, literally assemble the image bit by bit. Thus far the main emphasis has been on two things: (1) looking for distinctive shapes and (2) rapidly establishing those shapes with bold linework.

Now take a careful look at these sketches shape by shape. Study the individual shapes and compare them with the finished sketches to see how they work together.

1 In both pelicans start with the distinctive head, neck and bill shapes.
2 Then add the torso shape, which looks like a kind of lumpy sweet potato.
3 The tail feathers come next.
4 Next add the legs down into the feet.
5 Add the pier post underneath.
6 The shading then ties it all together.

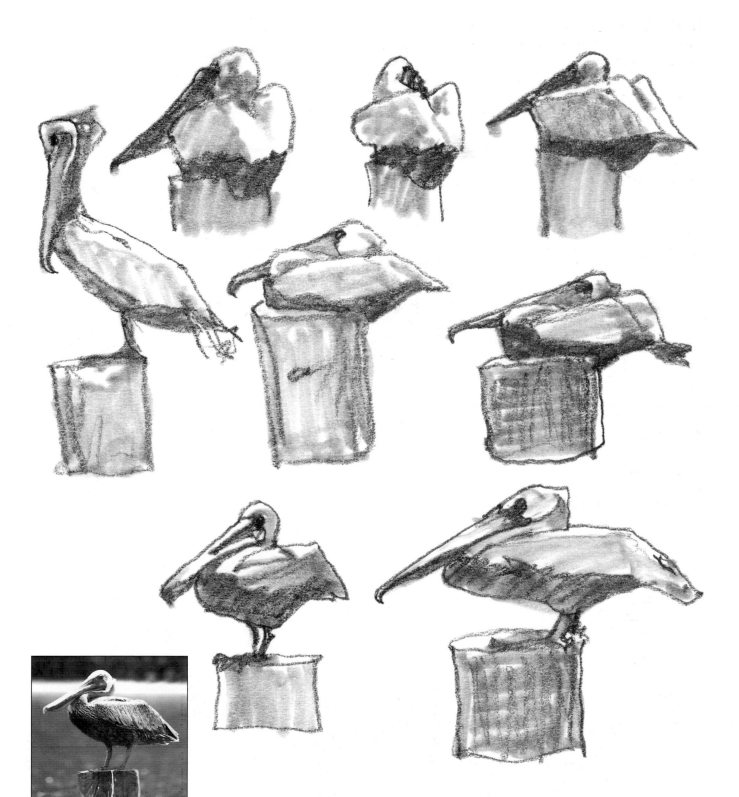

Deanna and I had spent all morning sketching and photographing the wildlife and landscape in the Ding Darling bird sanctuary on Sanibel Island. Then we drove farther out to Captiva Island.

Here is one of the pages from my sketchbook that day. Every pylon in the marina was capped with a pelican resting and dozing in the heat of the day. These pelicans are so used to humans in the marina that they allowed me to get quite close to them without flying away. Each sketch took only a couple of minutes, so I was able to sketch two dozen birds in various postures.

Take Mental Snapshots for Live Subjects

Live animals such as this clouded leopard cub are excellent subjects, but they require you to work very fast. You can see that I constructed these sketches with just a few shapes.

Take a mental snapshot, then draw fast. This is the key.

You have to look at your subject carefully. Take a mental snapshot of a particular posture. Hold it in your mind's eye for a few moments while you look down at your sketchbook and sketch.

While the mental image is still fresh in your mind, try to quickly sketch the basic shapes as shown below. This can be a real challenge at first, but with practice it becomes second nature.

Don't Always Start With the Head

I usually start with the head shape, but in this instance it was this large leg and thigh shape draped over the tree limb. Since I had only moments, I found that by delineating this shape the rest came easy.

Only after you've established the posture and critical elements should you even think about the spots. Then tie it all together with shading.

I did this entire page of sketches, beginning with the largest one, as a class demo in my Zoo Artists classes. I had the kids watch me draw the large sketch first. Then I showed them how to see the simple shapes that make up the cat. Finally, I showed them how to put it all together with the shading, tying the shapes and spots together into a complete image.

Two Shapes and a Tail

The sketch below is another from my Zoo Artists classes. On this day the male lion, who has a magnificent mane, was restless. He'd get up and pace about roaring and sniffing the air. Then he would plop his massive body down like dropping a bag of cement off a truck—*kerplunk!*

We had just started sketching class and the kids were totally bewildered by the idea of drawing this lion in such an agitated state.

It actually helped that he never faced us, but rather kept his eyes and ears trained on the enclosure door where the keepers would soon slide in his lunch.

I picked up my pencil, held my sketchbook high, and in thirty seconds drew these two shapes and a tail. Then I had the children look closely at the lion to examine the two main shapes I had identified.

Then all twenty of them drew these same two shapes quickly before the lion moved. Once they had drawn the shapes, I had them add the tail and then take the tip of their little fingers and smudge their drawings as shown.

It was miraculous! They got so excited that they had in fact drawn a live creature that it made the rest of the day perfect.

First Shape There are only two real shapes to deal with here. The first shape is the massive outline of his well-developed mane. Draw this shape quickly with a rather firm pressure. Then scumble in a mess of lines. Don't spend any time on these lines, however; they are only meant to provide some graphite for the blending tool to shade the mane.

Second Shape Then all you have to do is draw this back shape with the one leg slightly raised. Make sure that your lion is lying down by making the bottom of this shape relatively flat, as though it's lying on the ground. Draw a light line down the middle, indicating its spine, then lightly shade this as shown.

The Tail Now that you've got the lion's basic shapes, give him a tail and some light shading with your blending tool. Could this be any easier?

It Doesn't Take Much . . .

I'm always looking for designs that catch my eye. These hippos in the Cleveland Metroparks Zoo fit the bill nicely. You can see that to sketch these creatures, all you have to do is combine a bunch of rounded shapes together and then carefully shade them.

How can I get more detail in sketches of live animals?

When working with live subjects, you can do an initial sketch and then use it as reference for a second or third sketch. The idea is simple: Sketch something as fast as possible in order to catch a specific movement or moment, then use that sketch as reference to do another more slowly.

In the first sketch, try to capture some basic features, postures or details. Look at the subject more than at your page. Do a number of these kinds of quick snapshot sketches until you get something you like. Then focus on the first sketch that you like and use it as reference for another sketch.

In this second sketch, slow down dramatically, spending more time on the subtle linework and shading. If you need to clarify something not in your first sketch, you can always glance back up at your subject to observe and gain needed information. I highly recommend this procedure and have a good example of it here for you to study.

A silverback gorilla at
Cleveland Metroparks Zoo.

Above is my first sketch of a large silverback gorilla. He had been highly agitated about something within his family troop and was thunderously charging about his enclosure exerting dominance over all the other gorillas.

Then, in an instant, he came to rest right in front of me, with his massive back in my face. As he sat there, master of his limited domain, with almost half of his rear end hanging off the rock, I rapidly did this little sketch trying to capture some of the massive power of this great ape.

I actually did a whole page of quick sketches from this vantage point, but the first one was my favorite. I used this sketch as the reference for my second sketch on the top of the next page, only looking back up at the silverback occasionally.

This is an extremely helpful sketching technique, for your subject can get up and move at any moment—which he did shortly after I finished this initial sketch. This way you can capture something very quickly, then refine it at a leisurely pace. I use this same procedure with people.

In these gorilla sketches, the sketching sequence was as follows:
1 The entire torso, back and head.
2 The support arm.
3 The other arm.
4 The tiny bit of a hand at the end of the support arm.
5 And finally the rock that he was perched on.

This was my second sketch using the first as a reference. It was done using the same 9B graphite pencil as the first.

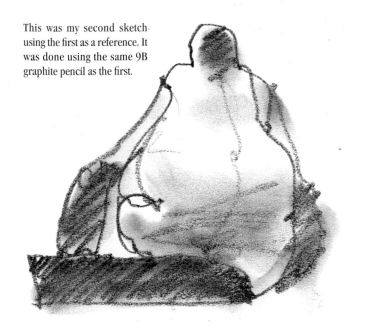

Then I tried one using my 6B charcoal pencil. This pencil is blacker and softer than the 9B graphite.

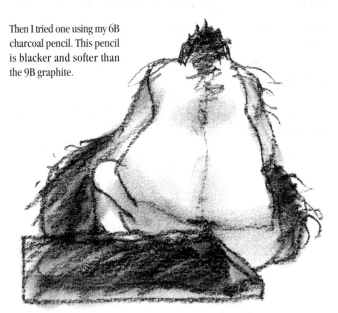

Notice how in the second and third sketches above I was able to slow down and try a bit more shading and details. The first sketch took only a minute or two; these took three to five each.

This technique helps eliminate one of the most difficult and frustrating aspects of working with live subjects. It allows you to use your fastest skills to quickly capture something about your chosen subject, and then you can create a better sketch at a slower pace.

I'll refine a sketch two or three times on location. This way I still have the subject before me if I need more information. I back it up with some slides as well.

These smaller sketches are additional first-generation sketches as the gorilla moved about the enclosure. You can see how I rapidly sketch through structure to define a shape, then tie it all together with shading.

Later that evening, back in my studio, I did this watercolor study on Arches rough water-color paper.

Developing Ideas From Sketches

In 1992 the Cleveland Metroparks Zoo commissioned me to create the inaugural poster for the grand opening of its rain forest facility.

We decided upon a singular image of the orangutan. Over the next three months I spent numerous hours at the zoo studying these creatures, looking for postures and behaviors that would make a good painting and would translate well into a poster format.

This is the kind of project where good sketching skills really help. Below left are a few sketches from my first efforts with the orangutans. They consist of quick shapes catching only the basic postures of the orangutan as it crouched on a rock.

For several weeks, this is all I did. Posters have a long life and I wanted just the right pose. The rest of these sketches were done back in my studio working from slides and field sketches done on-site.

Orangutans at the Cleveland Metroparks Zoo rain forest facility.

After a couple weeks of sketching, I began to focus on a few ideas that had emerged in my mind. I needed to refine these ideas, which required that I get a number of excellent 35mm shots of the orangutan in very specific postures.

This is no easy trick. The lighting in the old Monkey House left much to be desired. I worked with the keepers in timing my visits to the orangutans' natural food and rest cycles. I didn't want to use my flash equipment to take the shots; that would disturb the animals and create an image in which the lighting and colorations were distorted by the flash.

Eventually I was able to shoot enough images that I could work in my studio effectively. It was when I did this studio drawing at right that I knew I was on the right track.

This is the image I eventually settled on for the finished watercolor. I had a hard time making the final decision. Virtually any of these images would have worked well, but I had observed this one orangutan stretch out like this again and again. He would grasp the rope with his hand and foot, extend himself out at extreme angles, and then drop into a big swinging arc across the enclosure. I liked the visual tension this posture created.

To do these sketches I worked on heavy-weight vellum tracing paper instead of in my normal sketchbook.

This is a standard trick/technique that professional illustrators use. I do the sketch on the front side with only the linework and then work with the shading on the back side of the vellum. The thickness of the vellum creates an actual visual depth to the sketch. It also softens the shading a bit, providing some nice subtlety.

These drawings took about fifteen to twenty minutes each. So, according to my definition, they are in fact drawings rather than sketches.

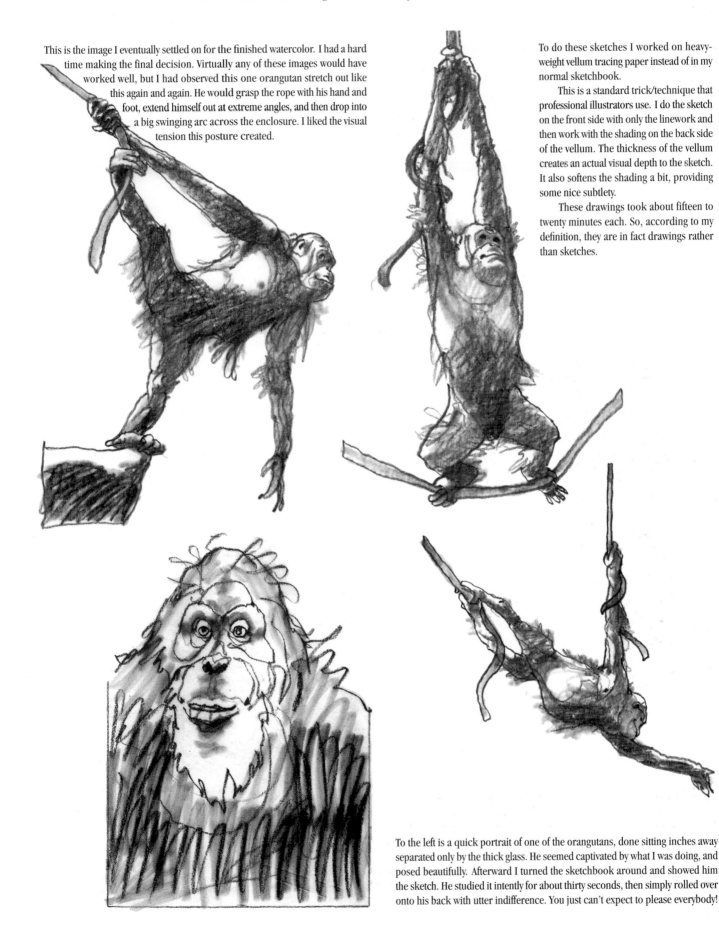

To the left is a quick portrait of one of the orangutans, done sitting inches away separated only by the thick glass. He seemed captivated by what I was doing, and posed beautifully. Afterward I turned the sketchbook around and showed him the sketch. He studied it intently for about thirty seconds, then simply rolled over onto his back with utter indifference. You just can't expect to please everybody!

123

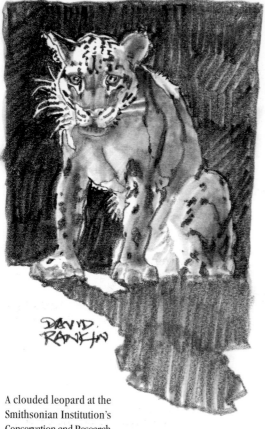

A clouded leopard at the Smithsonian Institution's Conservation and Research Center in Front Royal, Virginia.

Drawing vs. Sketching

By comparison you can easily see how much more refined the drawing of the leopard at left is than a sketch. With it I wanted to be careful to indicate the whiskers by defining their negative space with the surrounding dark background value. This way they would appear white.

This sort of careful detail requires more time to delineate than does sketching. Notice also how carefully the eyes are drawn, including the highlight in the eye reflecting off the bright foreground. I lifted this out with my kneaded eraser, something I would never take the time to do when I am sketching.

The shading of the midvalue gray indicating the leopard's coat was also done carefully, even allowing for a couple more whiskers that I cut in with the tip of my blending tool. I carefully defined the background and the leopard's cast shadow with many short, defined strokes, bearing down quite hard to deepen the dark tone. Then I shaded over these stripes lightly.

All of this takes time. I was working in my studio drawing from a projected slide I had taken. I had all the time I needed to noodle this drawing, which took about twenty minutes. When you are sketching fast, you don't have time for this kind of detail.

Notice the difference in the faster linework that created this tiger sketch. The shading was also done quickly and is therefore less precise. The facial characteristics are only hinted at, while the shadow is just a few quickly scumbled lines that are shaded lightly.

This is truly a sketch. It was done in only a few minutes while I stood in front of the Siberian tiger enclosure at the zoo with a crowd of about fifteen people watching me. The tiger was hot and restless, only holding still for ten to fifteen seconds at a time. I had to work fast under distracting conditions. This is when good sketching technique comes in handy.

Give this sketch a try by following my sketching sequence on the opposite page.

→

A Siberian tiger at the Cleveland Metroparks Zoo. Total sketching time was about two or three minutes.

Tiger Sequence

Study my steps for a few minutes. Then start with the first step and try to re-create this tiger rapidly. If it takes you more than three to five minutes, try again until you can work in that amount of time.

Stay loose and don't sketch lightly. Bear down a bit so that you can see any errors more easily.

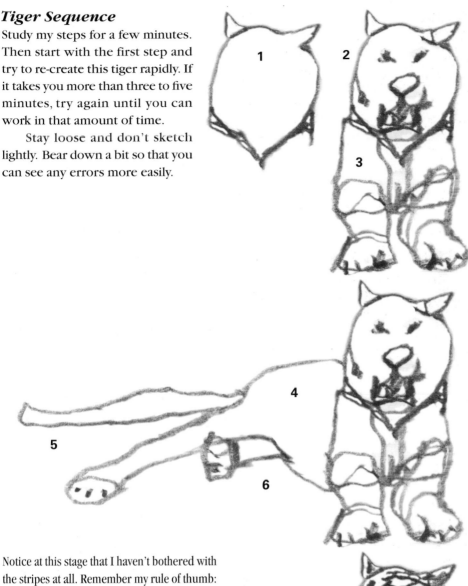

1 First, quickly outline the shape of its head including the ears. This establishes the placement of the head. Once this is done you can build the rest of the body from there.

2 Since the tiger was moving its head more than the rest of its body, I quickly sketched in the eyes, nose and mouth.

3 Once the head shape and face are indicated, attach the chest, legs and paws.

4 Then add the leg that extends out to the left.

5 Add the tail.

6 Next sketch the other piece of a leg and foot sticking out from underneath the tiger.

7 Add stripes on the coat of the tiger and quickly scumble in a cast shadow with a few light lines inside the shadow shape.

You can see how important the shading is by comparing the finished sketch on page 124.

Notice at this stage that I haven't bothered with the stripes at all. Remember my rule of thumb: Leave the spots and stripes until last!

This is the part of a sketch that had to be done the fastest because the cat kept shifting its posture in the heat.

← It was only after establishing the overall posture and shape of the cat that I could slow down and even think about adding a few stripes and details. Once I have this much it doesn't matter if the cat moves. I could still add stripes even if the cat lay down, which he did almost as though on cue.

Working Fast in Crowds

To the right is a sketchbook page showing three good-sized sketches I did of live eagles at the Smithsonian Institution's Conservation and Research Center in Front Royal, Virginia. I did these sketches in a large crowd that had gathered to see these rare birds. The large eagle at the bottom was the most spectacular. I quickly noted how he would repeat this posture every fifteen to thirty seconds, so I chose to sketch it in this position.

Sketching in crowds demands great concentration, because people love to watch you sketch. This can become a real distraction. Remember to follow the procedures by building your sketch piece by piece, shape by shape and then shading it in.

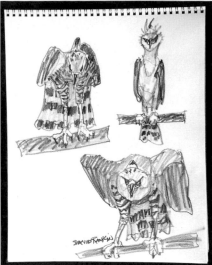

Sketching Sequence

As with most portraits of people, birds or animals, I started with the circular shape of its head as the eagle peered intently at me. You can easily make out the circular shape surrounding its eyes and beak.

Once the head was established I could then attach the wings, and then its long legs and feet. As you know by now, the bold dark markings on the legs and tail feathers were done last. Notice how some light shading provides just enough contrast to establish a light source and shadows.

Painting From My Sketch

This was such a great bird that the next day I did this watercolor study of it, working from the sketch I had done the night before to create this 18" × 24" (46cm × 61cm) watercolor.

If you can get used to using your blending tool in just the right way to establish your midvalue range of grays in a sketch, it then allows you to develop paintings much easier, either right there on location or back in your studio.

In this type of situation where photography is impossible you'll only have your sketching ability and your memory. This is what I mean when I say that being able to sketch effectively broadens your creative options and makes it possible for you to take advantage of unique opportunities that arise.

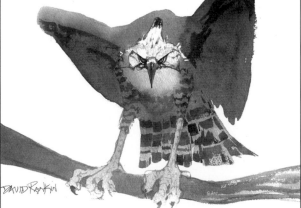

Developing a Complicated Idea in Minutes

Deanna and I have visited Goa, India, a tropical paradise on the southwestern coast of India, a number of times. I am always impressed by the sheer number of gray-headed crows that seem to be everywhere. They'll sit outside in the palms' fronds, as shown in the sketch below, and make a real racket with their raucous calls to each other.

This painting idea has been in the back of my mind for some time. Until I sketch an idea, I don't know if it will make a good painting. To test the design elements of an idea to see if it holds together, try projecting reference slides on a small rear-projection enlarger in front of you and rapidly sketching out ideas.

Review the following sketching sequence and give the sketch below a try (it took me about six minutes).

1 Sketch a light outline shape to delineate the outer reach of the frond tips. Then rapidly sketch the lower bird first, followed by the one that is right behind.

2 Carefully position the third bird at the top.

3 After establishing the positions and postures of the three birds, sketch each palm frond out to the light outline you started with. This actually should go quite fast. Start down in the lower left and progress upward, carefully weaving the fronds around the birds and establishing the central stalk of the palm branch for them to stand on.

4 Take your blending tool and quickly shade the midvalue gray tone down each frond and across the gray heads and backs of the birds.

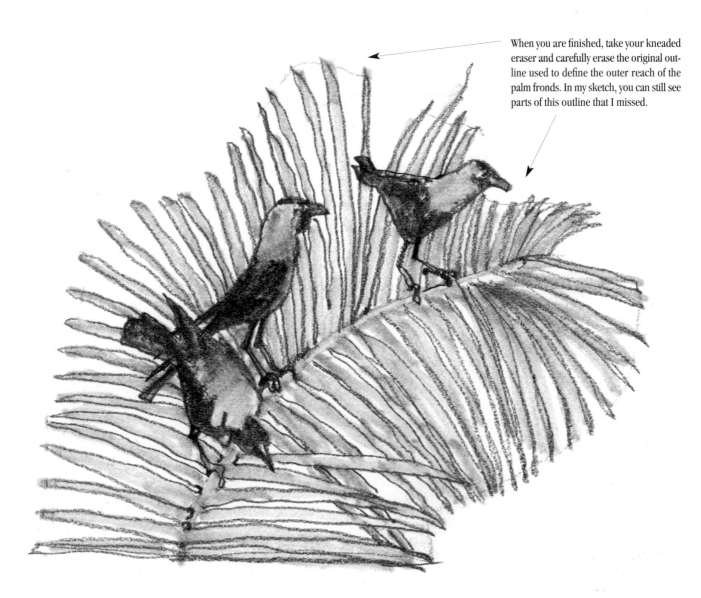

When you are finished, take your kneaded eraser and carefully erase the original outline used to define the outer reach of the palm fronds. In my sketch, you can still see parts of this outline that I missed.

Two Different Mediums

Hornbills are great birds to sketch. Their large distinctive shapes and markings make it easy. The graphite sketches of India's giant hornbill below were done in the New Delhi Zoo. At right is one of my quick watercolor studies done from this sketch in my studio. You can see how similar this graphite technique is to the watercolor study. This is why I love this technique; it allows me to think in watercolor while sketching in graphite.

Note how easy it is to create soft gray shadow tones throughout the sketch and establish a strong light source with one swipe of the blending tool.

The sketch to the right was my first sketch, done very fast with only the essentials of the posture and design. It was used as a reference for the one above. Sketch the distinctive features first, and fast!

1 These birds exhibit very dramatic postures, so always try to establish their head and beak shape first. Then building the body and tail is easier.

2 Add the torso shape next.

3 Follow with the puffy legs and feet.

4 This allows you to correctly place its distinctive tail.

5 The limb is hardly anything.

6 Then carefully blend and shade the sketch, adding the dark markings on the tail as well as its black facial mask. These are done last because they can be added even if the bird moves.

128

Think Fast and Improvise

I am fascinated by big birds. Some of the world's storks and cranes can grow to nearly six feet with gigantic wingspans. A few years ago I was working on a poster project for the International Crane Foundation, in Baraboo, Wisconsin. After two to three days' sketching and study at their facility, I had everything I needed, except for good study sketches of the crowned cranes. I was about to give up and depart.

As I was walking to my car, I saw two crowned cranes right near the fence, so I approached them slowly. I didn't have any of my sketching materials with me, but I did have a black felt-tip pen in my pocket. So I took it out and did the quick linear sketch (shown at right) on a piece of notepaper from my lapel pocket.

I was very happy with the sketch, and when I got home I took a watercolor brush with a little water and simply brushed over the sketch. This produces a nice watercolor-like effect that worked great. When you're in a pinch, use whatever works.

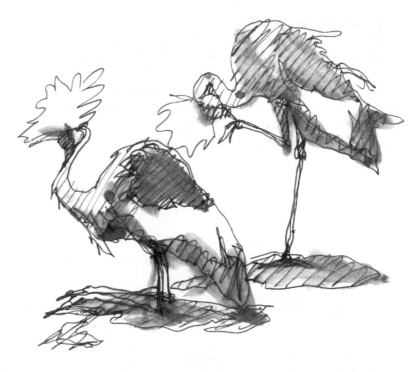

Here is a sketch of a different but equally beautiful bird, a harpy eagle at the Columbus Zoo in Columbus, Ohio.

1 I started by carefully drawing its beak and eyes.

2 Once the face was established, I proceeded to build the plumed head framing its face.

3 The rest of the body was added quickly and without much detail at all.

Here is another sketch of the same species of crane from the New Delhi Zoo, using my basic graphite pencil technique.

1 As usual, I did the head and crown first.

2 Then, I added the neck down to the torso.

3 Next came the entire torso shape, and I delineated the dramatic dark and light markings.

4 The legs were added last, and then the sketch was shaded carefully to indicate strong overhead light casting shadows over the crane's face and the neck.

Some Subjects Sketch Themselves

Elephants are one of my favorite subjects to sketch because they really only consist of a few large shapes that are fairly easy to define. I suggest you begin with the back end of the elephant. All you have to do is get the initial large shape—including the backside, spine at the top and legs and feet at the bottom—and you're almost finished. After you've sketched this shape, simply add ears sticking out in front along with some front legs, trunk or tusks and, of course, a tail. Then quickly add some shading for volume and you've got yourself an elephant.

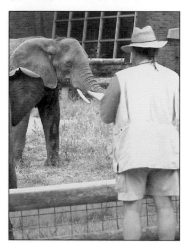

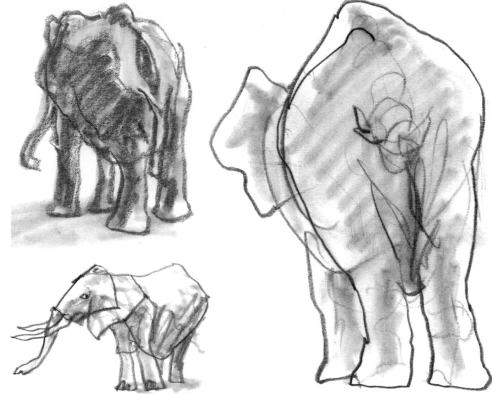

I did these elephant sketches at the Cleveland Metroparks Zoo. You can see how I simply draw shapes in order to establish them quickly. In the small sketch at right, what shape did I draw first? If you guessed the head and trunk, you're correct. Next I added the tusks and ears, and then I proceeded to add the large torso shape and legs. Shading the graphite creates a unifying effect that makes the sketch read as a whole.

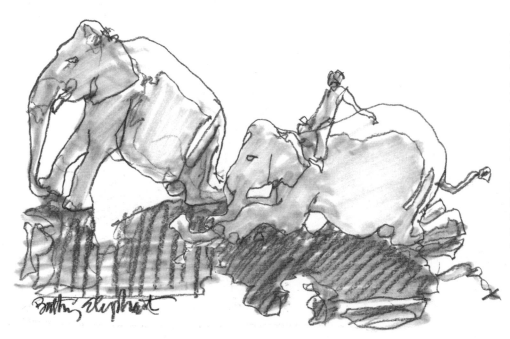

Elephants, both wild and domestic, have been an integral part of the daily fabric of life, culture and religion in India for over five thousand years. So it never surprises me when we happen upon them in unusual places.

I love to sketch and paint them in the late afternoon when the mahouts—the elephant keepers—take them to the river to cool off. It's such an exotic image.

Notice in this sketch how I simply outlined the unique postural shapes of the elephants, and then outlined the massive shadow shapes as well. It's the shading that ties it together. I added the rider only after I had drawn the elephant.

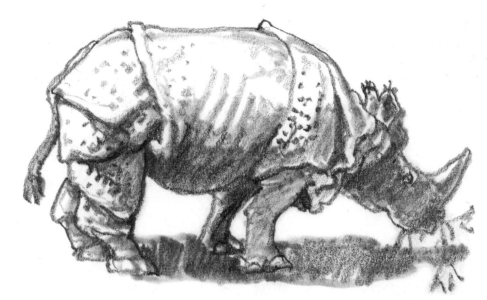

Unusual Animals Make Great Subjects

Both this one-horned rhino and the large crocodile below make excellent subjects for sketching. These were both done following my basic procedures of assembling an image out of parts. With the rhino it's easy to see these parts, because the rhino is actually structured like armor plating.

In sketching this crocodile, I started with the outer contour line of the upper jaw and continued on around building its head and mouth. The folds that make up its body were easy and fast. I added the teeth last, and shaded in and around them with the tip of the blending tool.

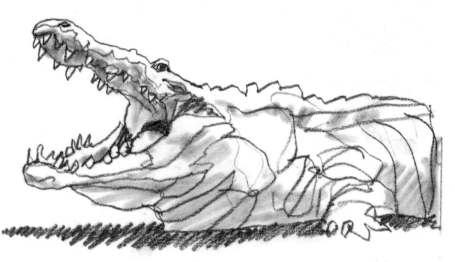

Try this sketch of a bull seal. Look carefully at the initial linework below. This is the part of the sketch that has to be drawn as fast as possible. It's just the outline contour of the shape with some simple detail.

In live situations, you have to work fast, before the animal moves. The seal only held this pose for fifteen to twenty seconds before lunging back into the pool, so I had to quickly capture its essential shape.

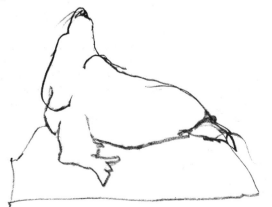

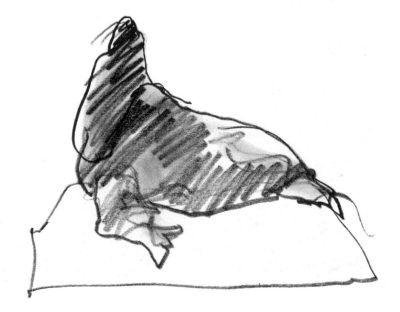

How can I capture the quick movements of very active subjects?

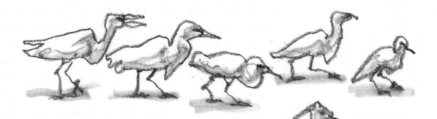

Notice how truly simple these outline shapes are. They are just a quick outline with a couple lines indicating legs and feet. It is the shading that gives them weight and volume.

Here is a difficult subject. I was in the New Delhi Zoo sitting on a bench under a tree, and a flock of about thirty cattle egrets swooped down across from me and started racing about eating bugs that were crawling around under the tree.

Capturing the essence of fast-moving live subjects like these takes careful observation of postural shapes coupled with fast sketching.

1 First, watch the head and beak of a bird for a moment, trying to spot a unique posture.

2 Then take a mental snapshot of that posture and quickly draw the outline only.

3 If you like the body posture with its neck, head, beak and torso, add the legs and feet with very simple linework.

Then, try another and another, simply adding them across and down the page. Each individual bird here took less than thirty seconds.

4 After you have done a dozen or so, switch to your blending tool and lightly shade the gray tone into their bodies and necks, and the cast shadows on the ground. This provides volume to the structure of the birds, as well as establishes a light source quickly.

Cattle egrets at the
New Delhi Zoo.

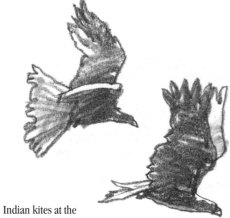

Indian kites at the
New Delhi Zoo.

During the months of February and March, New Delhi hosts thousands upon thousands of hawks, kites and egrets on their annual migrations.

There were literally thousands of these birds in the zoo on this particular day, so I was able to study their flight postures and shapes again and again as they lifted off, landed and lifted off again.

Rather than sketching several birds lifting off at once, these are actually second-generation sketches using faster first sketches for reference, and including a number of different birds over a twenty-minute period of observation.

Use a Camcorder in Sketching Active Subjects

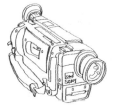

In the last few years I've developed a sketching technique using my Sony Camcorder with its side-view screen. This has become one of my favorite field techniques because with the camcorder I can take a wide assortment of images and footage, even under extremely difficult conditions and lighting situations. Then I can rewind the footage and freeze specific frames long enough to do a quick sketch.

This is an incredible imaging tool for situations where your subject is moving around so much that it's virtually impossible to get anything worthwhile quickly. This technique works for virtually any subject that moves very fast.

One of the great things about this technique is that the small screen forces you to deal with only the most important features of your subject. You can't see a lot of detail, so you tend to sketch faster and looser, which is ideal.

The freeze-frame features of these hi-tech camcorders are not really designed for this kind of use in that they don't usually have a frame-advance feature like many VCRs have. But when you're out on location and you only have a very limited amount of time to work with a subject, this technique just might help you succeed.

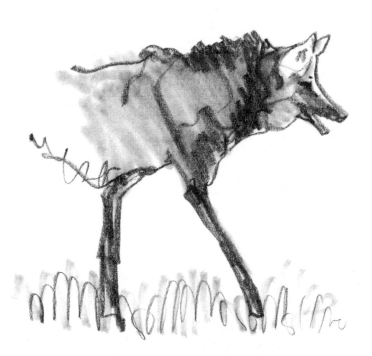

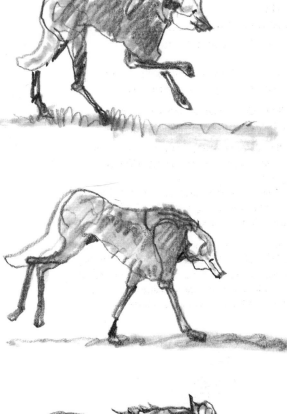

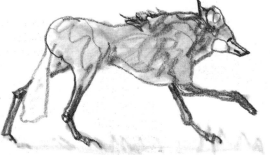

Recently I was visiting the Smithsonian Institution's Conservation and Research Center for some meetings in preparation for its Fall Conservation Festival and Art Exhibition. While there I was asked to do some sketches of the maned wolves. The wolves are nocturnal, so arrangements were made for me to come in early the next morning when the keepers fed the wolves.

The next day I was sketching five feet away from a rare South American wolf (shown above and at right). It hardly stood still for more than a fraction of a second. At first all I was able to sketch were fast, rough postural scribbles. As I studied its movements I was captivated by its long loping stride, accentuated by this species' extremely strong shoulders and long, thin legs.

I took the camcorder and laid down about five to ten minutes of footage, making sure that I got some video of it loping along in stride. Minutes after the keeper left, the wolf lay down, but because I had my camcorder, I was able to sit in my car and sketch from the side-view playback screen.

Within forty-five minutes I had done all of these sketches and many others. I had created valuable reference for future work, and the center had its sketches for immediate use.

Sometimes You Only Have Time for Singular Shapes

There are times when certain subjects defy your best efforts. Live, active monkeys are right at the top of the list. These Celebes monkeys at the Cleveland Metroparks Zoo were in a very excited state, having just awakened and been fed. They would come to a motionless position only momentarily before jetting off across their enclosure chasing one another.

Working this fast trying to capture some essence of their movements and postures requires intense concentration. But you can see from my sketchbook page below that I could not get much detail, only postural studies.

With subjects that are moving around this fast, you'll find that it really does help if you begin sketching the head position first. By placing the head position first you can then add the rest of the body easier and faster. There's no time for fingers and feet, ears or eyes—just the simplest shapes, almost as silhouettes.

The other thing to do with fast-moving subjects is to look for an overall shape rather than too many interior shapes. To sketch these shapes at high speed you have to work small. Big sketches take too much time. Judging how big or little to make your sketches takes some experience. My rule of thumb for active subjects is the more the subject moves, the smaller the sketch.

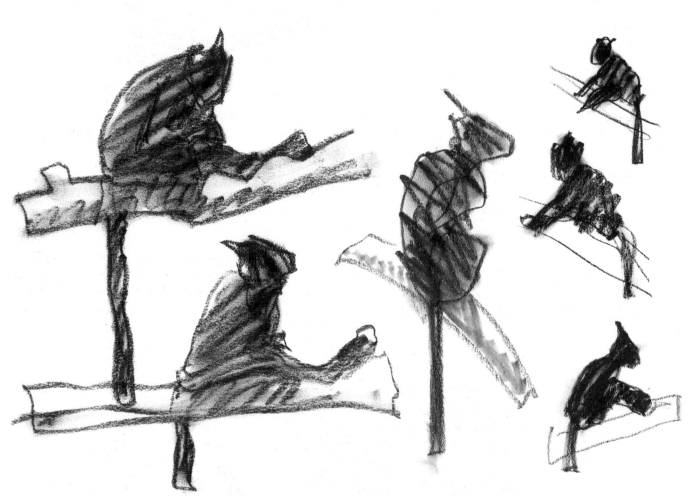

These monkeys are dark all over, with only a few white markings. Their most distinguishing feature is the tiny wisp of hair sticking up to a point on the crowns of their heads.

For these sketches, I used a 6B charcoal pencil that is softer and darker than my 9B graphite pencil. I would look closely at the monkeys as they struck a pose. In an instant or two I'd quickly capture that shape, hardly looking at the sketchbook page. Then I'd scumble in some quick fill lines and blend it with the tip of my little finger.

Langur Monkeys

Here are some of my favorite sketches of langur monkeys from our last exploration of Rajasthan. This is actually a second-generation sketch, similar to my second-generation sketch of the gorilla on page 121. I did this one after doing an early faster, rougher sketch of this langur leaping off the parapet of the Amber Fort.

Try this sketch following this sequence.

1 Start with the distinct face.

2 Then sketch the monkey's right arm from the shoulder to the fingers.

3 Complete the whole torso next.

4 Bring out the other arm and hand.

5 Now you're ready to add the right leg from the hip down to the knee.

6 Then do the leg from the knee to the foot.

7 Sketch the right foot, standing on its tiptoes as it takes off through space.

8–9 Quickly add the back leg and foot.

10 Carefully sketch the dramatic tail shape, adding a slightly darker line under its behind, indicating light source.

11 Rough in a stone ledge.

12 Carefully shade, preserving the white areas.

The sketch below is also a second-generation sketch done from initial, much faster postural studies. I started by delineating their faces and heads. The last things I sketched were their distinctive tails. Again you can see how important the blending tool is in sketches like these. It provides just the right gray value softly and subtly.

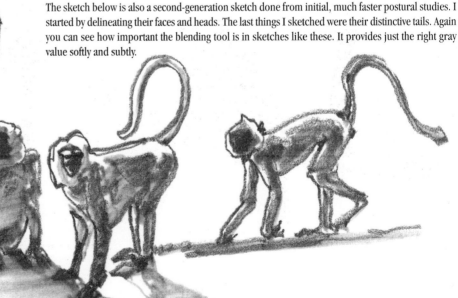

How can I remember fine points and keep ideas alive?

When you are working in the field with live subjects, a lot of ideas can be generated quickly. It's a good habit to use your sketchbook effectively to keep track of all kinds of subtle details that you might easily forget otherwise. Quickly sketch an idea and make various notes regarding lighting, colors and details you want to remember back home.

At right is a working painting idea I developed as I worked with the cranes at the International Crane Foundation.

A sketch of red-capped cranes, with notes included.

These are sketches of secretary birds at the Cleveland Metroparks Zoo. The large secretary bird at left strutted over in front of me and proceeded to root around in the deep grass looking for some tidy morsels to be stirred up. It was a summer afternoon and a good, stiff, hot wind was blowing, so every now and then the bird would stop its hunting for grasshoppers and stand motionless facing into the wind.

This gave me a good opportunity to jot down these quick sketches. You can see the distinct shapes and pieces I used to assemble each sketch, starting with the white head and neck shape, followed by the torso shape. Then I sketched the dark wing shape and finally the long legs down into the grass.

Also notice in the sketch to the left how I pressed down a bit harder with the blending tool as I shaded the tapered tail feathers, creating the natural gradation common to this bird's feathers.

136

Sketching to Remember Later

At right is a quick sketch I did a few years ago after observing a large tiger trying to beat the one-hundred-degree heat in the shade of a dense bamboo thicket in India's famous Kanha National Park. I had the good fortune of seeing three tigers in two days, and the deep blue-gray shadows, speckled with golden greenish light breaking through the bamboo canopy, inspired me almost more than seeing this magnificent tiger.

When I returned to my camp I quickly scribbled off this sketch so that I'd remember the painting idea I'd come up with out in the jungle forest. This is how I get my best ideas. I see something that catches my eye and then work with the idea, mentally evaluating how I will re-create that specific effect, lighting or composition in watercolor. To further this process I'll whip off a few really rough sketches that help crystallize my inspiration. Once I do even the crudest sketch of an idea, I can then come back to it later and the initial sketch kick-starts my memories about the subject.

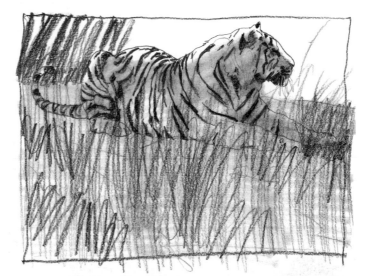

The sketch above at right was one I did when I got back home, taking the idea a bit further. In this sketch I had the idea of having the tiger lying in deep grass in the shade.

This is where the idea stayed for more than two years, until I was beginning the final preparation for this book. I was looking through my sketches and got excited about this idea once again. I spent the next week doing the watercolor at right.

This is how sketching works. It preserves your initial on-site experiences and perceptions in a visual format that can assist you even years later.

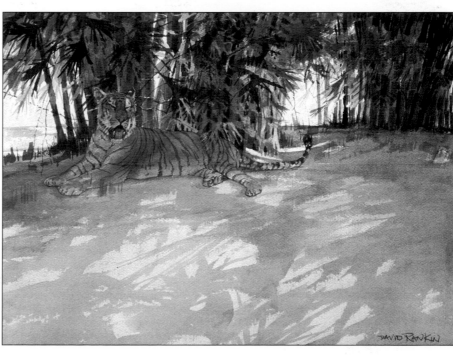

Bamboo Shadows
transparent watercolor
18" x 24" (46cm x 61cm)

Keep Habitat in Mind

Snow leopards live in some of the most inhospitable parts of Asia. I have traveled vast tracks of the Himalayas many times over the years but have never seen a snow leopard in the wild. They are just too elusive. So like every other artist who paints snow leopards, I've studied them in zoos.

The Himalayas are a vast primitive landscape that stretches before you, peak after peak, as far as the eye can see. It's an incredible landscape that inspires me like no other. So over the years I have developed and painted a number of watercolors of snow leopards that do include authentic landscapes and vistas. Many artists who paint snow leopards actually focus in very tight so that all you see is a big beautiful cat, lying about in rocks. This is because few have ever seen one in the wild.

For me, however, the landscape is as important as the cat, for its remarkable habitat defines this magnificent creature. These sketches are all from my various expeditions and efforts to create a definitive work depicting this big, beautiful cat.

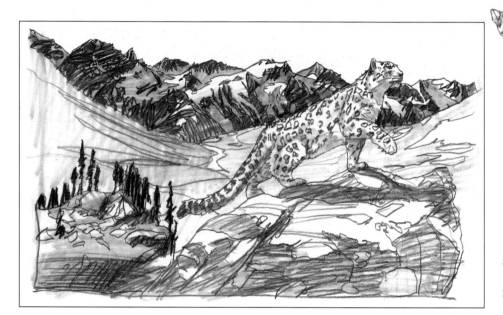

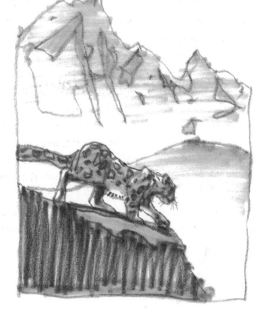

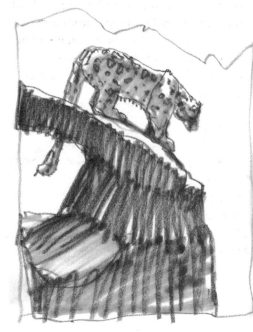

The study at the top left shows an actual ridge in Kashmir near Mahagunas Pass. The pass is at an altitude of 14,500 feet and lies along an ancient pilgrimage route through the inner range of the Kashmir Himalayas. Our horseman told us how the shepherds seldom take their flocks into this far ridge of mountains because this is where the shors live—the big cats!

I keep getting new ideas for paintings of snow leopards going about their solitary lives in these high peaks and eventually I paint them. Until I do, though, it's my sketches that keep these ideas alive and fresh in my mind. Sometimes it's years before I fully develop the ideas.

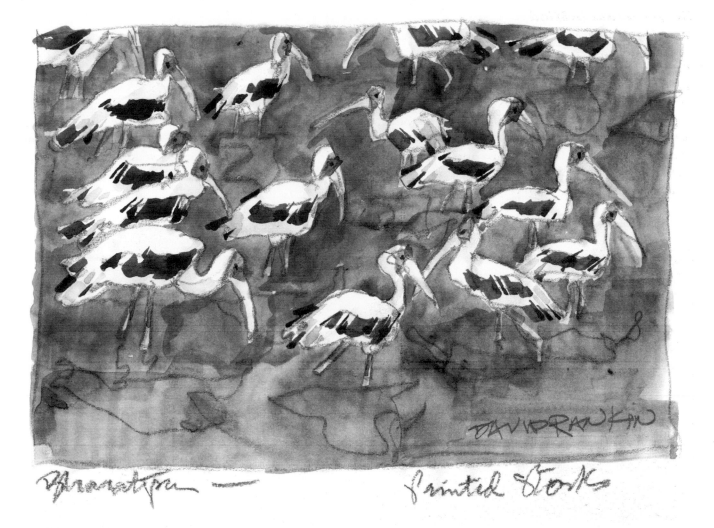

Bharatpur — Painted Storks

Take Sketches a Step Further With Watercolor

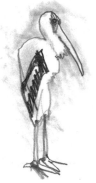

Upgrade your sketching skills so that they serve you creatively. The idea is to sketch in a manner that allows you to think through painting or sculpting ideas quickly and effectively, both in your studio and in the field.

As soon as you feel confident in your sketching skills, try this advanced technique: Finish your sketch—developing your ideas, designs and compositions—then, instead of shading the linework with your blending tool, paint it with watercolors or acrylics.

The image at the top of this page was done in my hotel room after a day's intensive sketching in India's Keoladeo National Park in Bharatpur, an astounding water bird sanctuary. Working with my field sketches from that day, I quickly roughed out a painting idea based on my experiences with large feeding groups of painted storks.

I had run out of heavier watercolor paper, so I used a sheet of very lightweight stock that wrinkled badly with the water. But I wanted to try out this idea while everything was still fresh in my mind. Even though the paper warped, I still love this study, for it did indeed capture the essence of my experience.

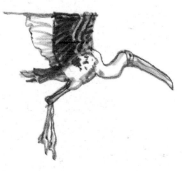

Artistic Freedom

Your ability to create memorable paintings begins with your ability to develop creative ideas on location, in a direct visual relationship with your environment and subject. I need this creative connection through my sketches in order to do my best work.

Once I've sketched and studied in the field, I can then implement my ideas into finished paintings. For me, sketching has been an incredibly liberating experience. Although I use photography extensively as a backup tool, it is not my primary imaging source for my creative energies.

My ability to sketch and paint in the field has liberated me from a slavish dependency upon the photographic image. I hope that you also can experience this same artistic freedom in your life.

Right: *Meditation*, watercolor, 24" × 18" (61cm × 46cm)
Below: *Jungle Shadows*, watercolor, 20" × 30" (51cm × 76cm)

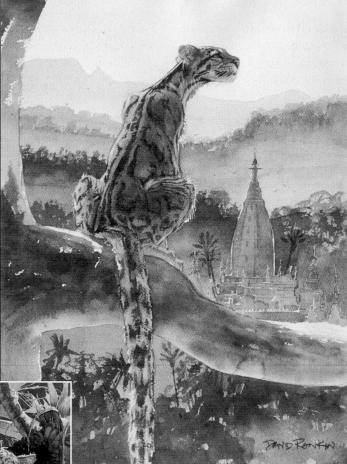

Last year I was commissioned by the Smithsonian Institution's Conservation and Research Center to create a painting of its resident clouded leopards for an inaugural fine art poster. After three to four days of sketching sessions next to their outside enclosures, I had enough material to create not just one but many paintings of these magnificent and elusive big cats of the Asian mountain forests. The painting to the left was the one I created for the CRC. I did more than sixty sketches on location, and back in my studio I did another twenty sketches, several composition studies and six full-color watercolor studies.

Although the original artwork, to the lower left, was completed over a year ago, my initial intensity for an idea, once established, can go on for years. I become visually fascinated with a subject, and strive again and again to create something new and fresh. My original sketches fuel my artist eye and imagination with new ideas and compositions. And before you know it, you've got a whole new slant on a painting. The painting above is my most recent effort to do justice to this remarkable species of cat.

I wanted to end this book with what I consider to be some of my very best examples of the techniques that I've presented. Remember, practice makes perfect. The more you sketch, the better your skills will become.

Index